THE
RUSSIAN
LINESMAN

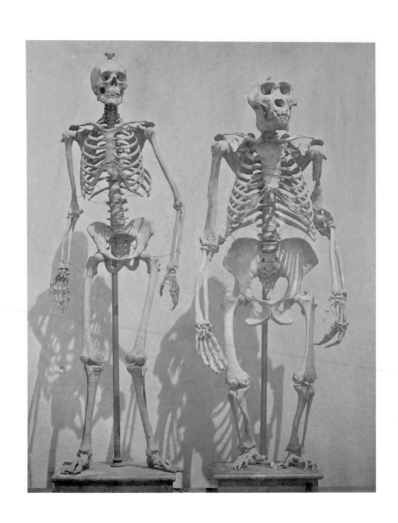

MARK WALLINGER

THE RUSSIAN LINESMAN

FRONTIERS, BORDERS AND THRESHOLDS

HAYWARD PUBLISHING

PUBLISHED ON THE OCCASION OF THE EXHIBITION:
MARK WALLINGER: THE RUSSIAN LINESMAN
A HAYWARD TOURING EXHIBITION

EXHIBITION TOUR:
18 FEBRUARY–4 MAY 2009, THE HAYWARD, LONDON
16 MAY–28 JUNE, LEEDS ART GALLERY
18 JULY–20 SEPTEMBER, GLYNN VIVIAN ART GALLERY, SWANSEA

Frontispiece: Roger Fenton, *The Skeletons
of a Man and a Male Gorilla*, c. 1854–58

AWAKE IN THE NIGHTMARE OF HISTORY

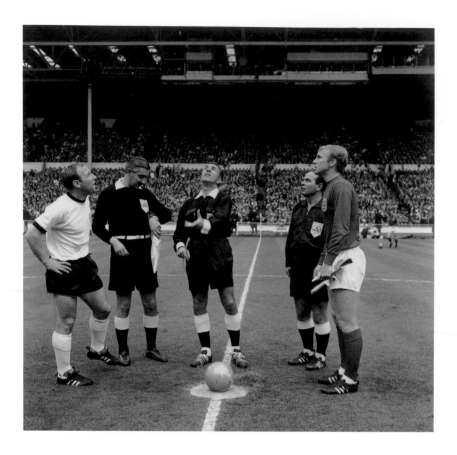

World Cup coin toss, 30 July 1966

Awake in The Nightmare of History

1. London: 30 July 1966

England play West Germany in the World Cup Final at Wembley. It is twenty years since the War ended and this is the first competitive meeting between the two nations.

After 90 minutes the score is 2–2 and the match goes into extra time. England take the lead with a shot from Geoff Hurst that hits the underside of the crossbar, and bounces back in the field away from the goal. The Swiss referee hesitates, but then sees that linesman Tofik Bakhramov has raised his flag, signalling that the ball crossed the goal line.

England go on to win the game 4–2.

The linesman's decision is still hotly debated. In England, it is generally held to be correct, while in Germany it is usually regarded as a mistake.

After the match, newspaper reports referred to Tofik Bakhramov as the 'Russian Linesman'. He was actually from Azerbaijan, a nation that had been annexed by the Soviet Union. In the West, the adjective 'Russian' was a blanket of ignorance thrown over the whole USSR.

Tofik Bakhramov (1926–1993) was originally a footballer, but a serious leg injury prevented him from continuing his playing career and he became a referee. Nevertheless, his role in this match altered its history as much as any of the players involved, and the national football stadium in Baku is named in his honour.

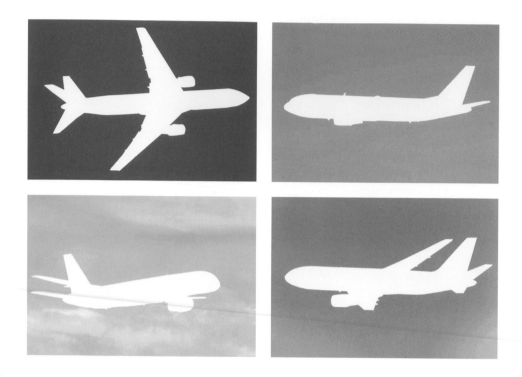

Mark Wallinger, *Four postcards*, 2001

2. Berlin (i): Monday, 10 September 2001

I was walking around the Aviation-Centre, a shop on Kantstrasse in Berlin which has models in many gauges of civil and military aircraft, and an encyclopaedic collection of postcards of every conceivable type of airborne craft.

I bought four cards. At home, I used a scalpel to fillet out the airplanes from the blue sky. I stuck a card on each of the four walls of the living room so that the white walls voided the excised planes.

The following afternoon, Anna and I were sitting in the kitchen. The BBC World Service makes oppressive listening at the best of times, so we decided to walk to the Bauhaus home store for some inspiration. As we stood in line with our meagre purchases, I became aware that the German reporter on the radio was sounding more than usually animated. I caught the words 'World Trade Centre…'

'I think they've destroyed the Twin Towers.'

'Don't be silly.'

We went back to the apartment and there was a message from my sister, saying simply: 'Turn on the TV.'

I have a confession to make: I didn't see the first tower collapsing and I regret missing the spectacle.

I took the postcards down from the walls.

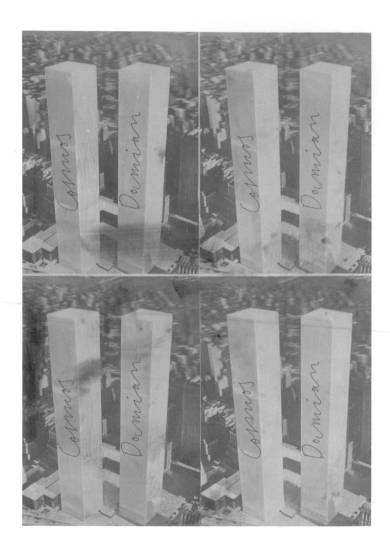

Joseph Beuys, *Cosmos and Damien Polished*, 1975

Nothung!

(He lifts his ashplant high with both hands and smashes the chandelier. Time's livid flame leaps and, in the following darkness, ruin of all space, shattered glass and toppling masonry.)[1]

The fall (bababadalgharaghtakamminarronnkonnbronntonnerronn-tuonnthunntrovarrhounawnkawntoohoohoordenenthurnuk!) of a once wallstrait oldparr is retaled early in bed and later on life down through all christian minstrelsy.[2]

Joseph Beuys had his own version of the Twin Towers, naming them Cosmas and Damian after the early Christian physicians and martyrs, patron saints of pharmacists.

Twin brothers Cosmas and Damian practised the art of healing in Syria. They accepted no pay for their services and were therefore called anargyroi, 'the silverless'. Through their work, they brought many converts to the Catholic faith.[3]

When the Diocletian persecution began, the Prefect Lysias had Cosmas and Damian arrested and ordered them to recant. They remained constant under torture, and in a miraculous manner suffered no injury from water, fire, air, nor on the cross, and were finally beheaded with the sword.

In Arab culture the brothers symbolise racial harmony. In a depiction known as the 'miracle of the black leg', Saints Cosmas and Damian replace the gangrenous leg of the Roman deacon Justinian with a leg from a recently buried Ethiopian Moor.

On the morning of 14 July 1902, the floating city of Venice woke up to a low-pitched, quavering sound.

Overlooking the square of San Marco, the Campanile, the 325-foot tower that was a symbol of the city's power and prosperity, forever its pride, shivered, shook, and collapsed.

On itself.

Like that.

In a cloud of masonry dust.

A miracle for the busy crossroad – markets unfolding, churches congregating – that no one was hurt.

A kid picked up a brick to look at it. It was unbroken, as were the million others – a miracle of a different sort. The brick was passed to someone else. A human chain soon formed. Each brick was retrieved, cleaned, and stacked.

By evening, it was decided the campanile would be rebuilt com'era, dov'era: *as it was, where it was.*

Before midnight, posters announcing the news, and printed free of charge by an old typesetter, were pasted all over the city by its proud inhabitants.

A new tower, an exact replica, was inaugurated in 1912.[4]

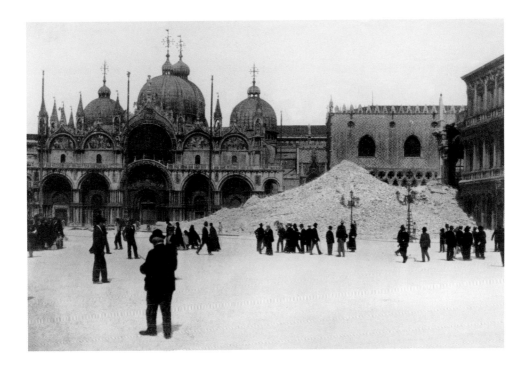

View after the collapse of the Campanile at
St Mark's Basilica, Venice, Italy, 14 July 1902

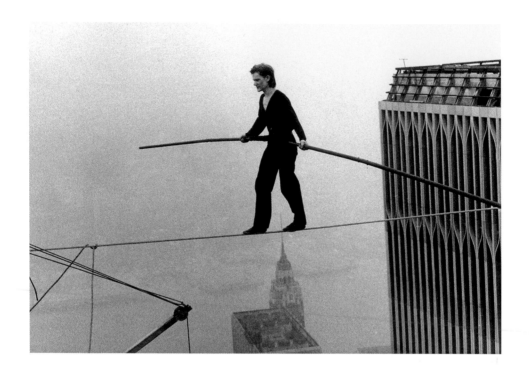

The French high wire artist, Philippe Petit, walks
across a tightrope suspended between the World
Trade Center's Twin Towers, New York, 1974

3. New York (i): 1980

It is late summer and I am in New York. Like innumerable tourists, I take photos of and from the Twin Towers. I remember being out on the roof, giddy with the audacity of these twins that were to die within minutes of each other, watching light aircraft flying beneath us.

At the time I don't think I was aware of Philippe Petit's high wire act. During the night of 6–7 August, 1974, Philippe Petit secretly – and illegally – strung a wire between the still-unfinished twin towers, a quarter of a mile above ground level. At daybreak, he stepped off the South Tower onto his ¾ inch steel cable and gave a high-wire performance that lasted until he was forcibly brought down an hour later.[5]

The redemptive power of art – is that a fat old lie? When the act precedes the atrocity by 27 years? In 1974, NBC news showed footage from a helicopter circling round and round a barely visible thread between the buildings.

Nearly a decade later in 1983, the French theorist Jean Baudrillard interpreted the Towers' duality as signifying not only the end of all competition, but also the end of verticality. He described the World Trade Center as 'the visible sign of the closure of the [capitalistic] system in a vertigo of duplication.'[6]

Asked if he believed any force in the world had the ability to disturb this tactical doubling of forms, of monopoly in duopoly, Baudrillard replied: 'Islam.'

I am staying at the YMCA. Every night brings an electric storm and a classic film on the TV. I am researching my thesis on James Joyce's *Ulysses* at the City Library reading room, where I sit breathlessly waiting for another first edition to be brought to me and placed gingerly on two foam pads.

> *I flew! my foes beneath me… Fabulous artificer… History is a nightmare from which I am trying to awake.*[7]

One blisteringly hot day I head across the small park behind the library. A young black man in T-shirt and jeans joins me.

'Give me the camera,' he says.

I walk on.

'Give me the camera. I've got a gun.'

Increasing my pace a little, I risk a glance at him. There is nowhere that he can conceal a gun.

We reach the corner of 40th and 6th Avenues and the story changes. 'You see the guy with the baseball hat – he's a friend of mine and he's got a gun…'

I make it to the subway unmolested. Later, after my friend Chris joins me, we walk downtown. Somewhere near Wall Street, something smashes to the ground. It is a plant pot. Earth and terracotta shatter with unbelievable violence. Pots start raining down from high above.

We start running.

Mark Wallinger, *Zone*, Münster Sculpture Project, 2007

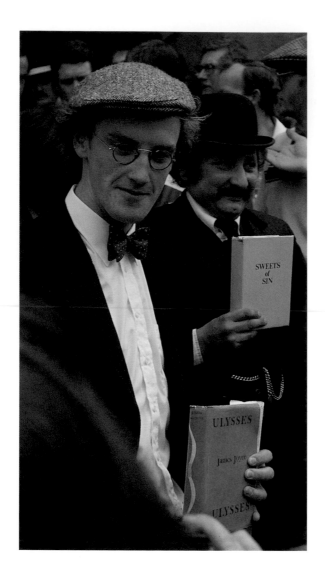

James Joyce centenary celebrations, Dublin, 1982

4. Dublin: 1982

In 1982, I went to Dublin for Joyce's centenary celebrations. I stayed at the YWCA which was partly housed in a Martello Tower on Sandymount Strand, where the Proteus chapter takes place.[8]

'Ineluctable modality of the visible.' Because all things are bound up in inescapable change, what is the nature of reality? Does an object exist if no one sees it? Does a sound exist if no creature hears it?[9]

A woman was selling oranges on O'Connell Bridge. That night I read about her in *Ulysses*. On Bloomsday actors re-enacted the Wandering Rocks chapter dressed in Edwardian costumes. A woman stood alone by a wall where a tobacconist's counter once stood. When the man playing Leopold Bloom bought a copy of *Sweets of Sin* from the Merchant's Causeway, an ironic cheer went up.[10]

The crowds pressed close to the Liffey as he prepared to cross to the Ormonde Hotel – as we all knew he would, since it's in the book. I raised my camera to take Bloom's picture. 'Sir! You've got your lens cap on,' he cried, which isn't in the book.

Outside the hotel, teary-eyed men pressed radios to their ears – RTÉ was broadcasting an unabridged reading of *Ulysses*. Word got back that they were selling Guinness at 1904 prices…

Later in the week, I was having a drink with a Canadian woman in the pub nearest to the Guinness Brewery. It was a known Republican haunt but she had been a barmaid there so, despite my London accent, I wasn't worried. However I was to have my own encounter with The Citizen. Picking up his bottle, he clubbed it down on the edge of the table…[11]

Photo of Babelsberg film set, 2004

5. Berlin (ii): 2004

I had driven to Babelsberg a number of times, drawn somehow to the fenced-off back lot which sits bizarrely within the villas and woodland of this prosperous Potsdam suburb. One end of the ersatz 'Berliner Strasse' served as the Warsaw Ghetto for Roman Polanski's *The Pianist*, while the other end became the Bronx of the 1950s in Kevin Spacey's biopic of Bobby Darin.[15]

Now I was back as an accredited visitor in a bear suit, because my more immediate interest was the fact that the studios continued after the war and produced *The Singing Ringing Tree*.[16]

In truth, the whole of Babelsberg, with its parks and castles, feels like a film set. Here was where the world was portioned out after the Second World War, and here is the Glienicke Bridge, where the spies were swapped during the Cold War.[17]

Sleeper. A bad conscience. Double agent. The bear. His story is a nightmare from which I am trying to awake. On the seventh night a second bear appeared outside. The security cameras picked it up. *Mein Doppelganger.* Identical in every particular, his paws framed his face, pressed to the glass.[18]

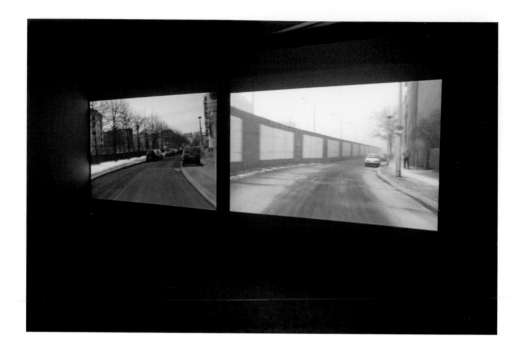

Amie Siegel, *Berlin Remake*, 2005

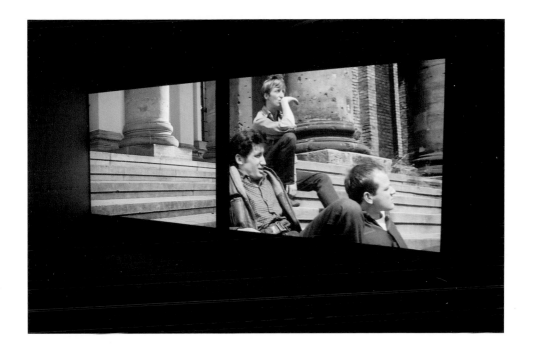

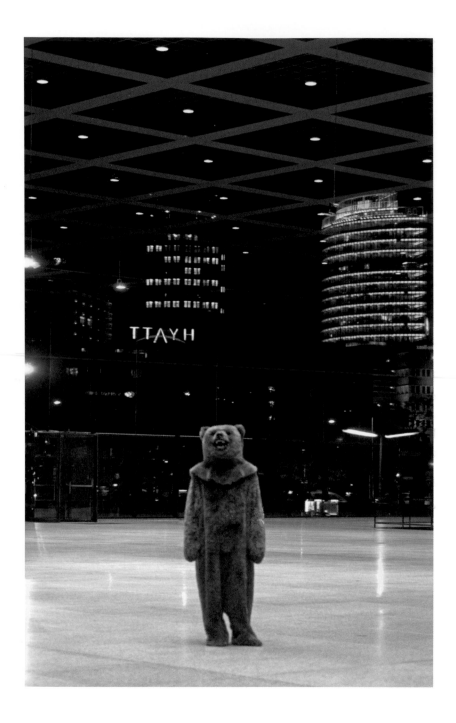

Mark Wallinger, *Sleeper*, 2004

Sleeper, Neue Nationalgalerie, 2004

Diary, Night 7

The weirdest thing happened. As we leave the building Isabelle's nephew, Moritz, who has been taking photos, asks: 'Have you seen the other bear?'

'The other bear?'

'Yes, the other bear.'

We follow him around the side of the building. Towards the rear, through the glass at the back of the gallery, is a bear behaving like a practical, or at least as able, a bear as me. It is the *doppelganger* of my suit and at this moment it is entirely alone, but unnervingly unapproachable. I feel threatened. As we walk round we discuss whether to speak to the bear or not.

'It's your call,' says Anna.

I realise I am a little intimidated and v. tired. From the other side comes a young woman who was sitting on her own at the front of the gallery when we were waiting to see Moritz. She sits next to the bear on the wall overlooking the church. As I approach them both, the bear walks away.

I ask the girl, 'Is this your friend?'

'No – looks like the bear has broken out.'

> *In Babelsberg, tongue-tied over their short history and in grief at their estranged brothers and sisters, they turned to their long past for some unexpurgated truth. The two realms of Germany were like twins separated as children and raised in completely contrary ways. Having to cross irrevocably from one realm to another, or be divided without appeal. This is what I have learnt and it seems very cruel. Germany invented the unconscious, which is not normally credited with respecting borders.*[19]

Our friend K's father was a doctor. Her family tried to escape to the West with K and her twin sister hidden behind the back seats of their car. They drove for hours in complete silence until they reached the border. It didn't work. Their parents were imprisoned and the girls sent away to a state boarding school.

K knew the story of the prince who was turned into a bear, and the selfish princess who learns to be kind and so her sullied beauty returns. *The Singing Ringing Tree*. When the Ritzy screened it in 1991 there was a queue around the block – a self-selecting demographic. As the picture flickered into life there was a collective gasp from the audience. The colour was overwhelming, a Grimm secret kept in Babelsberg for all those years.

> *Being alone in a museum was a delicious recurring dream of mine, to trespass among objects of such inestimable value. But an empty museum, what would that be, exactly? I have met many people who preferred the Jewish Museum empty of exhibits. Why? Something to do with Freud and the return of the repressed, I suppose. Because what do we dream until we know what we have done? The characters in fairy tales are hapless innocents – they do not yet inhabit a moral universe.*
>
> *Bauhaus is our house, Gretel.*[20]

Germany: our unconscious our angst, our trauma – *das Es, das Ich*, and *das Über-Ich* – and every action was once an idea or a dream. *Einfuhlung* literally means in-feeling, the placing of human feeling into inanimate things, plants, animals or other humans in a specific way.

All early American psychologists, including William James, were educated in Germany.

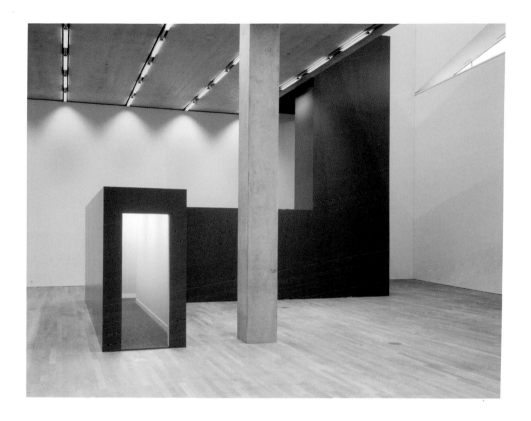

Monika Sosnowska, *Corridor*, 2006/2008

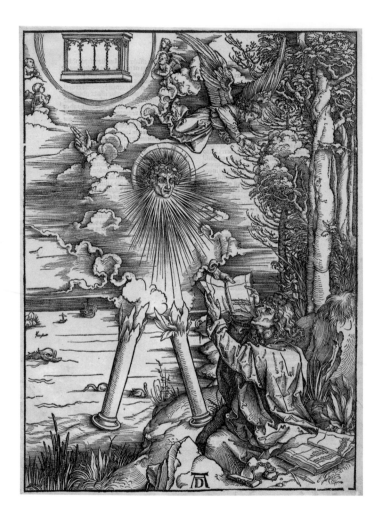

Albrecht Dürer, *Apocalypse* [St. John Devouring the Book], c.1498

6. Epiphany

Although *Finnegans Wake* is as vast and unknowable a piece of dreamwork that exists within the covers of a book, Joyce was deeply sceptical of the efficacy of psychoanalysis. Initially, Joyce's interest in dreams was pre-Freudian in that it looked for revelation, not scientific explanation. Later, he dismissed the symbolism of psychoanalysis – a house is a womb, a fire is a phallus – as being mechanical.

Despite this antipathy, he arranged for his daughter Lucia to see Carl Jung while continuing to deride psychoanalysis both publicly and within *Finnegans Wake*:[21]

> *We grisly old Sykos who have done our unsmiling bit on 'alices, when they were yung and easily freudened, in the penumbra of the procuring room and what oracular comepression we have had to apply to them!*[22]

Nevertheless, the Joycean epiphany as outlined by Stephen Dedalus in an early version of *A Portrait of the Artist as a Young Man* and Freud's idea of over-determination of symbols in *The Interpretation of Dreams* together construct a kind of psychic Vitruvian man at the centre of a web of his own making.[23, 24]

Freud borrowed the term from geometry, in which two lines are said to determine a point and three lines to over-determine it, while Joyce borrowed from Christianity the idea of revelation, *quidditas*: a radiating point of meaning.[25]

Mrs. Batterson

3-3-66

Dear Mrs. Batterson
 I am so glad
you are better now. We
like Ethel's cooking very
much but I cannot eat
Mince pies they make me
sick. Our little dog is
very well He sleeps in his
Box most of the time and ,

he eats very well. I expect
you have a nice garden
where you live. It was
my father's Birthday on
the 2nd of February and
they gave a Party in Paris
for him there were a lot of
people there. I hope to see
you soon when you come
up one of these days.
 With much love
 from Lucia Joyce

Letter from Lucia Joyce, 1966

In April 1993, my aunt, Barbara Tidman, sent me a letter from her
daughter-in-law, Jan, together with a letter written by Lucia Joyce
[left]. Barbara wrote: 'Lucia was at Moulton Park, Northampton. Jan
lived about 200 yards down the road and used to play in the gardens
there as a child. She wishes she'd taken more interest but of course
to kids they were just a lot of old loonies! The home has gone now
and there is a college – Nene College – on the site.'

> *I am so glad you are better now. We like Ethel's cooking very much but
> I cannot eat Mince pies they make me sick. Our little dog is very well he
> sleeps in his box most of the time and he eats very well. I expect you have
> a nice garden where you live. It was my father's Birthday on the 2nd
> of February and they gave a party in Paris for him there were a lot of
> people there. I hope to see you soon when you come up one of these days.
> With much love from Lucia Joyce. 3–3–66*

Her father had been dead for twenty-five years.

Epiphenomenalism is the theory that mental events are caused by
physical events in the brain, but have no effects upon any physical
events. Behaviour is caused by muscles that contract upon receiving
neural impulses, and neural impulses are generated by input from
other neurons or from sense organs.

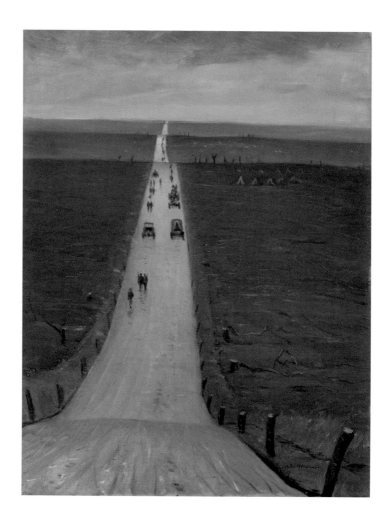

C.R.W. Nevinson, *The Road From Arras To Bapaume*, 1917

7. Jerusalem: 1998

On 15 February 1942 my father was on a troop ship rounding the Cape of Good Hope bound for Singapore when news reached them of the city's fall to the Japanese. Consequently he spent the majority of the war in Jerusalem and Beirut.

I first visited Jerusalem in 1998, prior to a proposed exhibition, with an American and some German artists and curators. We were staying in the Mishkenot Sha'ananim which was the first area of Jewish settlement outside the Old City walls, built by the nineteenth-century British-Jewish philanthropist Moses Montefiore.

We were taken round the old city by a wiry old guide who was in no hurry with his explanations. Before we started he asked each of the Germans among us where they were from, and in reply remarked dryly that he once had a brother who lived there, or a sister-in law from such-and-such. A man of infinite patience. 'I thought he was going to show us every stone in Jerusalem,' Florian said that evening in the café jointly owned by Israeli and Palestinians.

The next day we met Jack Persekian, who runs the only gallery dedicated to contemporary art in the Christian Quarter of the Old City. He drove us into the West Bank, where our first stop was an exhibition by an Arab artist in the Ramallah Art Centre. There was a self-portrait on the artist's card. It was only when I got home I realised this man was my *doppelganger*.

We pressed on further into the West Bank and arrived at a small township, what the UN would call a 'refugee camp'.

We were in a public square full of men, not a woman in sight. The men were voluble, friendly rather than threatening; before long we had accepted the hospitality of two brothers and were taken to their home.

The walls were cast concrete, roughly finished both inside and out. There were ten or twelve white plastic patio chairs around the sides of the room. Tea was made and we settled down.

'What do you think?' asked one of the brothers. I was about to be politely and unforgivably English, when Kasper replied: 'It is completely and utterly unacceptable.'

It was a story of three generations of struggle, waste and pain, told with incredible openness and goodwill. In common with their friends and neighbours, this family's sons had all been imprisoned following the first Intifada.

October, 1999

The site of the exhibition, *The Sultan's Pool*, took its name from the depression outside the walls of Jerusalem. The word for 'Hell' in Hebrew is 'Gehenom'; some Jewish traditions place this valley at its entrance because in ancient times it is believed that idolatrous practices (particularly child sacrifices to Moloch) were practiced here.

I spent a week in hell. The hotel baked in the sun all afternoon. No air conditioning, threadbare curtains and whisky that failed to anaesthetise the dread I felt.

The Golem is brought to life from dust when Jews are threatened with tales of the blood libel.[30]

William Blake, *Jerusalem: The Emanation of The Giant Albion*, 1804–1821

Louis Léopold Boilly, *Ivory Crucifix*
Hanging on a Wall, 1812

Vija Celmins, *To Fix The Image
In Memory XII*, 1977–82

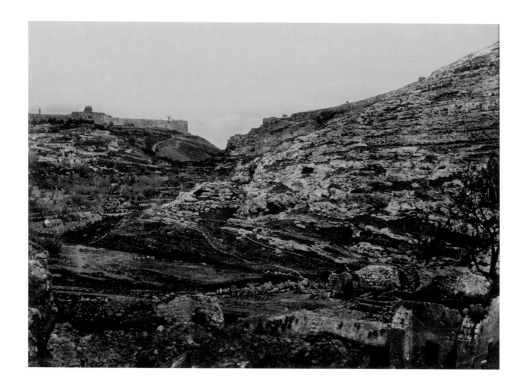

Frank Good, *View of Jerusalem*, 1866–67

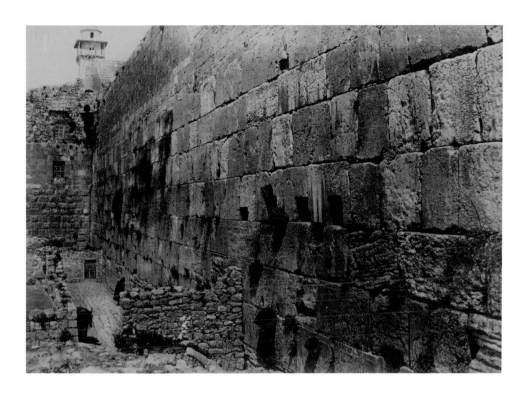

Frank Good, *Wailing Wall, Jerusalem*, 1866–67

One might consider Goethe's late poems as a starting point in meditating upon the West's idea of the East. A refuge for the imagination: an eroticised and fabulous land where one might meet one's reflection, or lose oneself through the looking glass. The West is not examined in return because its authority is not threatened. The Analyst has no reflection. The land of dreams is therefore to be regarded as the analysand; Omar Khayyam cushioned and reclined. The Unconscious, the Muse, the Fountainhead. Poetry.

Richard Carline, *Jerusalem and the Dead
Sea from an Aeroplane*, 1919

Martian Terrain, Twin Peaks in super resolution, 1997

North and West and South are breaking,
Thrones are bursting, kingdoms shaking:
Flee, then, to the essential East,
Where on the patriarch's air you'll feast!
There to love and drink and sing,
Drawing youth from Khizr's spring.[32]

Awake! for Morning in the Bowl of Night
Has flung the Stone that puts the Stars to Flight:
And Lo! the Hunter of the East has caught
The Sultan's Turret in a Noose of Light.[33]

Was it a vision, or a waking dream?
Fled is that music: – do I wake or sleep?[34]

The raising of Lazarus and Christ's own third day resurrection are fables of loss; Thomas's incredulity mirrors that which we all feel when someone is gone, vanished, extinct. It is not the theory of evolution that creationists fear as much as the certainty of extinction. Save teleology for cartoons. Simple curiosity is threatening, daring, amoral. Thomas pokes around in Christ's viscera. 'Except I shall see in his hands the print of the nails, and put my finger into the print of the nails, and thrust my hand into his side, I will not believe.' His incredulity is the madness of the sceptic betrayed by believers.

In Caravaggio's painting [right] we are both inside and outside, implicated and removed, believer and non-believer. We can choose to empathise with the wounded man, the man with his finger in the wound, or the rubbernecking bystanders. Not a story, but the moment, an epiphany, like Christ being taken in the garden in the Caravaggio painting recently found in a Jesuit Rectory in Ireland. Christ's passive head Janus-faced with the cry of a distraught St. John, like the impossible dream of escape.[35]

But if Christ had not been betrayed, where would we be now?

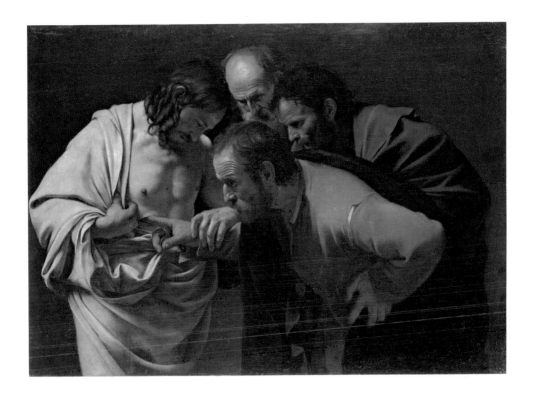

Caravaggio, *The Doubting Thomas*, 1602–3

Mark Wallinger, *UN Post on the Green Line*, Nicosia, 2006

8. Cyprus: 2006

13 April 2006. No Man's Land in Nicosia [left]. The abrupt landscape of conflict. There is an airport, abandoned when the Turks invaded, with one grounded aircraft and the summer of 1974 locked in the terminal. The Ledra Palace Hotel, newly completed at the time of the invasion, serves as the headquarters of the United Nations peacekeeping force.[36]

Missing persons. Never knowing what happened to someone you loved.

'When Will I See You Again?' was a hit that year.

Linda Herzog, *Lake Van*, Turkey, 2006

The cranes are still poised above Famagusta. A small sandy beach runs up to the fence, the barbed wire and the Turkish security post. A bored soldier waits to see how near we might come. The beach is deserted, apart from a couple of teak-coloured English pensioners. These mercenary retirees are big business on the North Coast of Cyprus. Homes stolen from their missing Greek owners are sold by a range of implausibly English sounding goons: Bentley, Churchill, Henry Charles Estates, Cherie Blair, you name them. Not dissimilar in a way to our original tawdry bargain with Turkey over safe passage to the Suez Canal. It was the Greeks that chased us out of here.[37]

Cross the Green Line and you tacitly acknowledge Turkish authority, which is still too much for many Greek Cypriots. Then you walk past the ubiquitous white painted oil cans with the UN letters, past the Ledra Palace Hotel and back in time to Turkish-occupied Nicosia. Kids play in the streets and the cars date back to the early 70s (lots of Renault 4s). The clothes are cheap and tacky, and the covered food market is dilapidated.

Two minarets now top the twin towers of what was an Orthodox Cathedral. Inside Moorish lattice work covers the windows. On the floor there is a myriad of carpets which ignore the orientation of the Church, being fixed on the diagonal towards Mecca. Everything else crafted over the centuries is extraneous, immaterial.

The Turkish invasion came at a very bad moment for Dickran Ouzounian. The Armenian car dealer had just taken delivery of 70 new Toyota Corollas and Celicas at his showroom in the heart of old Nicosia. Each had plastic wrappers over the seats and 32 kilometres on the clock, the distance from the port at Famagusta.

The fleet of cars sits there to this day, dulled with powdery dust, stuck in no man's land between the razor-wire of this divided city.

As fate would have it, his building was right on the United Nations ceasefire line. Nothing has been touched since. Nearby, the opulent Olympus Hotel is crumbling slowly in the heat, a home only to lizards.[38]

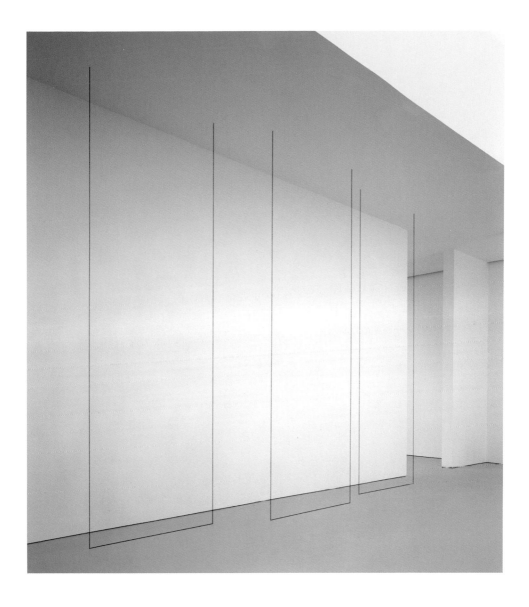

Fred Sandback, *Untitled (Three-part*
High-relief Construction), 1999

Bojan Šarčević, *It seems that an animal is
in the world as water in water*, 1999

9. Eruv

In simple terms, an *eruv* refers to a boundary – either real or symbolic – that surrounds a Jewish neighbourhood, and permits the carrying of articles within its borders. The strict prohibitions on public behaviour on the Sabbath are circumvented by this creative interpretation of the law. This loophole allows for a designated public space to become domesticated by a cord stretched as 'lintels' above 'doorways' into a communal home.

The Talmud recommends that it should be an integral part of the city and invisible to the untrained eye. This assertion of religious communal identity, quite discreet to the outsider, is the reverse of the ghetto. Here Jews were banished into forced communality, with a curfew curtailing their freedom of movement, quite the opposite of the laws and customs observed for the Sabbath.

Mark Wallinger, *Zone*,
Münster Sculpture Project, 2007

The island of Manhattan is an *eruv*.

In March 2002 an *eruv* was created in a section of north-west London.

Do you remember playing a game of tag at school in which you could cross your fingers and declare 'fay knights', a sort of street injunction that rendered you briefly immune to the normal rules of the game?[39]

Perhaps art exists in such an interregnum.

> *In a work traversed by a thread, the sensation of void precedes the perception of the work. Space precedes it. It is only gradually that space ceases for us to be the neutral and homogenous container of the piece and becomes its modulated, lived material, as well as the substance of our experience.*
>
> *The progressive accumulation of discrete perceptions finally amounts to the realization that we, as viewers, are dwelling in the same space as the work, and might even be within. The work thus comes with the pang, the vertiginous loss of identity – for in it the distinction between interior and exterior breaks down.*[40]

Frank Good, *Brick Pyramids, Israelitish*, 1872

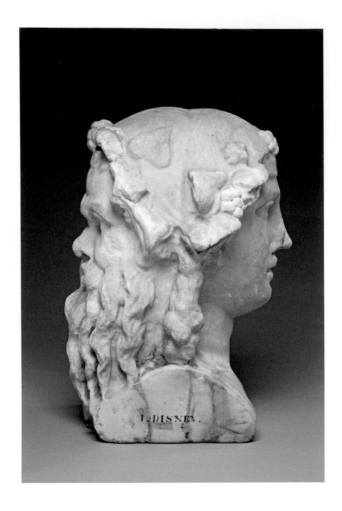

Anon, *Double Headed Herm, with Heads of
Dionysos and Bearded Silenus*, Early Roman

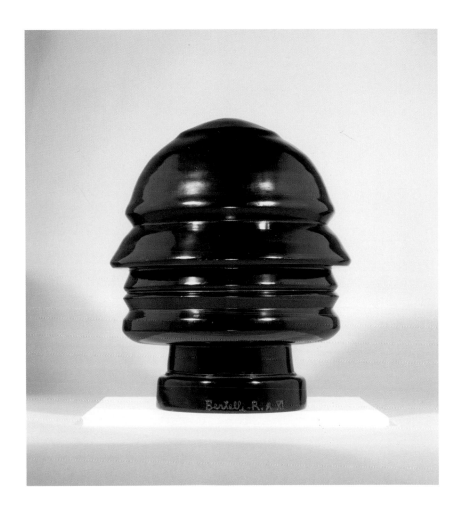

Renato Giuseppe Bertelli *Profilo
Continuo (Testa di Mussolini) [Continuous
Profile (Head Of Mussolini)]*, 1933

o

Zero is a number that quantifies a count or an amount of null size; that is, if the number of your brothers is zero, that means the same thing as having no brothers, and if something has a weight of zero, it has no weight.

If the difference between the number of pieces in two piles is zero, it means the two piles have an equal number of pieces.

Before counting starts, the result can be assumed to be zero; that is the number of items counted before you count the first item and counting the first item brings the result to one. And if there are no items to be counted, zero remains the final result.

Almost all historians omit the year zero from the proleptic Gregorian and Julian calendars, but astronomers include it in these same calendars. However, the phrase Year Zero may be used to describe any event considered so significant that it serves as a new base point in time.[41]

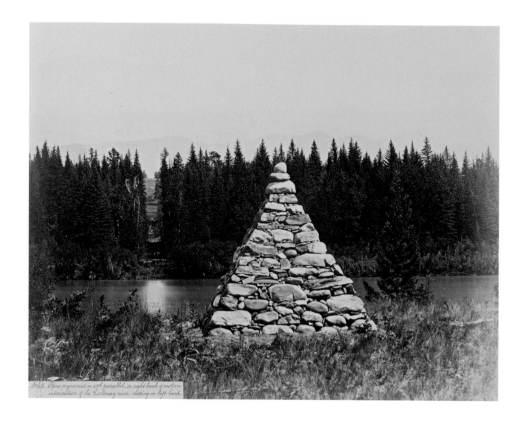

Anon, *Stone Pyramid on the 49th Parallel, on the Right Bank
of the Eastern Intersection of the Kootenay River, Cutting on the
Left Bank*, photographed by a Royal Engineers photographer on
a US-Canada Border Survey, 1860–1

o

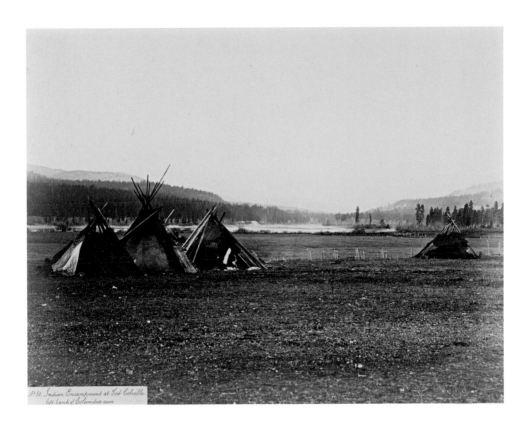

N°50. Indian Encampment at Fort Colville
left bank of Columbia river

Anon, *Indian Encampment at Fort Colville, photographed
by a Royal Engineers photographer on a US-Canada Border
Survey*, 1860–1

Cricket Wicket Painted on Wall, 2008

10. New York (ii): 2008

Twenty-eight years later, I have been invited to make a proposal for Governors Island, which lies in the heart of New York Harbour, only 800 yards from Lower Manhattan. It is 'a world unto itself, unique and full of promise. For almost two centuries, Governors Island was a military base...' according to the city guide.

The grassy area around which range the colonial style buildings summons up the image of a cricket match. I find it pleasing that on this island, which was once part of the British Empire, a game that has been embraced in virtually every ex-colonial country is played by a diaspora of Indians, Pakistanis and West Indians.

The length of a cricket pitch is a chain, an old imperial measure. Upon this space, a day-long ritual is played out, entirely mysterious and opaque to native New Yorkers.

I thought it would be nice to try and introduce the viral image of cricket wickets painted on walls around New York, a cult or gang identity, perhaps. I made a drawing and grabbed a couple of images from the internet and realised with a shock that this sign, familiar from my youth and still ubiquitous in Delhi, Islamabad, or Kingston, is a graphic depiction of the twin towers.

What has been done cannot be undone.

The distinguished curator was describing a book he had read recently which had an entirely new approach to history. The writer was a clairvoyant, and by analysing the signs apparent in the earlier stories of a nation's progress he could make an uncanny fit with his predictions and events that transpired. Young artists sat in rapt attention, but I had to ask, 'How can a book about the past be clairvoyant? Does it have a final chapter predicting future events?'

'No,' came the reply. 'It is entirely retrospective.'

Edweard Muybridge, Bird in Flight
from *Animal Locomotion*, 1887

11. Apotheosis

This really happened:

The scene: Le Bourget airport, Paris, 16 June 1961 (Bloomsday).

Nureyev's decision to defect to the West was not premeditated, but his hand was forced when the KGB, alarmed at his fraternisation with Western dancers, withdrew him from the Kirov tour. Hearing the news at the airport, he was able to get word to the French police. One account has two French policemen and two KGB agents in a tug-of-war with Nureyev in the middle.

> *Nijinsky knew himself only when he was dancing. His mind was blocked, constipated, and so he went mad. Even when you dance in Russia, you are terribly compressed. I had the feeling that if I didn't try everything, then my life would be wasted. Still, I would never have had the courage to do it unless they goaded me.*[42]

The leap to freedom for Nureyev was like the apotheosis of *Swan Lake* – betraying his Odette for the West.

In the second paragraph of his memoirs Nureyev describes his moment of crisis and places himself on the tarmac, beneath the aircraft bound for Moscow:

> *Its huge wing loomed over me like the evil magician in* Swan Lake. *Should I surrender and make the best of it? Or should I, like the heroine in the ballet, defy the command and make a dangerous – possibly fatal – bid for freedom [...] And then I made it – in the longest, most breathtaking leap of my whole career I landed squarely in the arms of the two inspectors. 'I want to stay,' I gasped, 'I want to stay!'*[43]

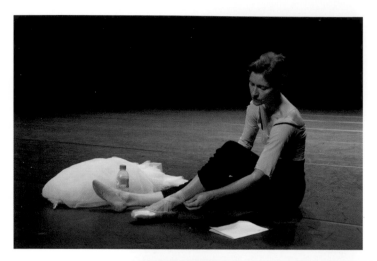

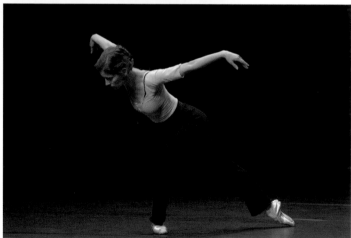

Jérôme Bel, *Véronique Doisneau*, 2005

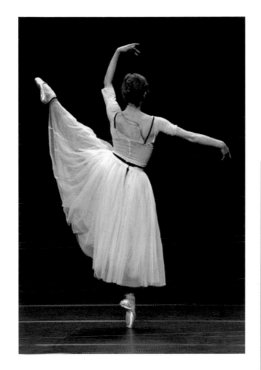

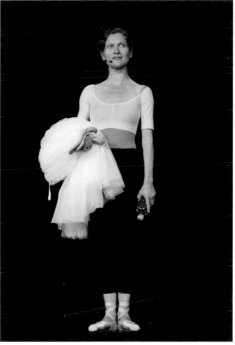

Swan Lake was the first and last ballet Nureyev danced with the Kirov. Alla Osipenko – 'the Odette of the Leningrad company', as the Kirov's Swan Queen was described in the London Press – was distraught at losing her Seigfried. In 1963, Nureyev danced *Swan Lake* with Margot Fonteyn in Paris.

> *In her list of professional terrors, Margot places* Swan Lake *at the top – a fear which was to remain with her throughout her performing life. As she wrote in 1989, in an epilogue to her children's story-book based on the legend: 'I think one should be aware not only of the duality of the Odette/Odile roles, of good and evil, but also of the duality within each role. Both are enigmatic characters; neither is what she seems. Odette is bird as well as woman. Odile is reality as well as illusion...'*[44]

Once in the West, Nureyev led a restless existence – perhaps inevitable, given his birth in transit aboard the Trans-Siberian express.

> *It seems to me very symbolic and revealing that I should have been born en route, in between two places. It makes me feel that it was my destiny to be cosmopolitan. Ever since I was born, I have had no real sense of 'belonging', no real country or house to call my own. My existence had none of the usual, normal limitations which make for a feeling of permanence and this has always left me with a strong sensation of being born stateless.*[45]

Nureyev's tomb [right], made to his instructions, is covered with the representation of a Kilim rug to signify this bisexual, exiled outsider as Tatar, Muslim, nomadic and stateless.

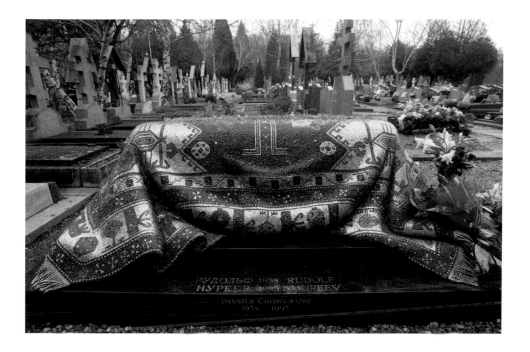

The tomb of Russian dancer Rudolf Nureyev, 2008

Bruce Nauman, *Revolving Upside Down*, 1969

12. Vertigo

The curious thing was that he was not here; he was somewhere else. On a high place ... looking down at this solitary figure picking its way between the shell holes. He thought: that's young Jim that little figure. I wonder if he'll make it ... He was an observer, not a participant. It was always like that in war though he had not realised it before. You were never you. The I part of you was somewhere else.[46]

Vertigo equals perspective plus gravity.

You don't grow out of it. At its worst, in the Whispering Gallery in St Paul's, I felt a tremendous energy, the urge to leap. Something in the building, the proportions, seems to encourage it.

The 'vertigo zoom' was devised by Alfred Hitchcock to depict a sense of extreme emotion. It represents a sudden rush of adrenalin. The description continues: 'The camera starts at a distance from the subject with the lens completely zoomed in. This is the start point. From here, when the shot begins, the camera tracks into the subject and at the same time the lens is zoomed out relatively so that the subject in the foreground remains the same size ... The opposite of this is the Zoom in/Dolly out. Once the shot begins, the camera starts to dolly out away from the subject while zooming in relatively. This gives a feeling as if the subject is growing closer or falling into the backdrop.'[47]

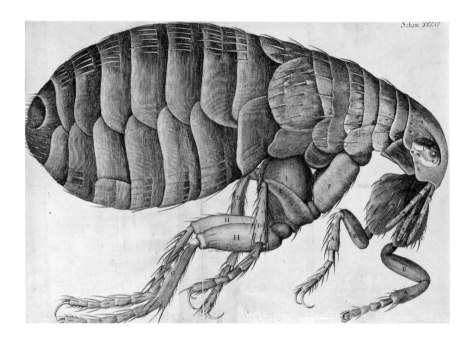

Robert Hooke, Drawing of a Flea From
*Micrographia: or some physiological descriptions of
minute bodies made by magnifying glasses. With
observations and inquiries thereupon*, 1665

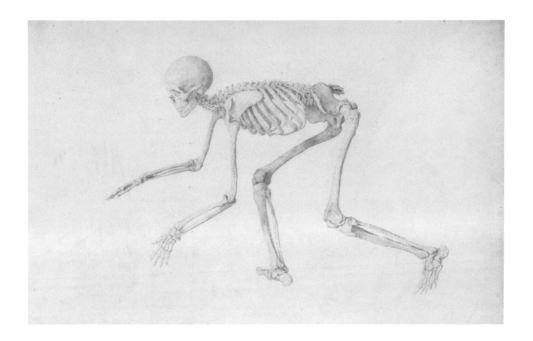

George Stubbs, *A comparative Exposition of the Human Body with that of a Tiger and a Common Fowl: Human Skeleton, Lateral View, in Crawling Posture*, 1795–1806

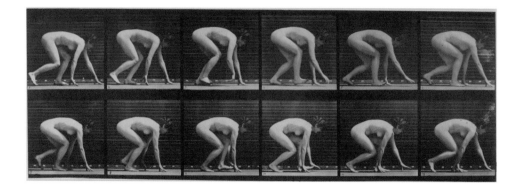

Edweard Muybridge, Woman Crouching
from *Animal Locomotion*, 1887

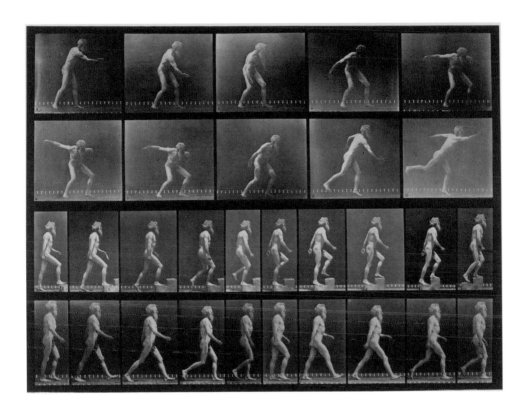

Edweard Muybridge, Man Walking and Throwing
a Discus from *Animal Locomotion*, 1887

I was a hungry reader, but an anxious one. I also had limited funds and was still deeply impressionable. None of which would stand up in a court of law.

There is a character in Saul Bellow's *The Adventures of Augie March* who steals expensive medical textbooks to order for impecunious students. I had a friend who was a prolific pilferer of books. Encouraged by his success, I steeled myself for a raid on Charing Cross Road. After much ado in various smaller shops, I decided it would have to be Foyle's or nothing.

It was a weekday and quiet, although I subsequently discovered around half the customers were store detectives. I must have made a pitiable spectacle, a mime of indecision and furtiveness in the midst of which the choice of book became immaterial. (It was *The Faber Book of Aphorisms*, edited by W.H. Auden and Louis Kronenberger).

I was apprehended at the door and accompanied to an office on the floor above the shop. There it was explained to me that police would be searching my flat. In the meantime it was likely that I would spend a night in Holborn Police Station prior to being charged. The head of security then left the room, locking the door behind him, leaving me to ponder the result of my actions. He was gone a long, long time. When finally he reappeared it was to offer me a choice: I could either be taken to the police station to make a statement, or I could pay for the book.

Some days passed before I had the slightest desire to look at the book, only to discover that a chunk of printed matter was missing from the back. This included the index which, for a reference work, made it singularly useless. Nor could I return it to the shop, not out of shame but because the receipt had the amount handwritten with the additional information in brackets: (SHOPLIFTING).

Ironically my first job after art college was next door in Collet's, a communist-run bookshop. Among the slew of political journals it stocked was *An Phoblacht* and therefore it seemed as safe as anywhere during the IRA's 'mainland' bombing campaign.[48]

In 1986 there was a Sinn Fein march in Islington. This attracted a strong counter presence from the British National Party, which had strong links to loyalist paramilitary groups in Northern Ireland. Afterwards the BNP attacked the Gay's the Word bookshop in King's Cross before descending upon Collet's. To cut a long story short, I got my head kicked in on a traffic island in the middle of Charing Cross Road.

After I left Collet's, it survived a fire bombing for stocking *The Satanic Verses*, but not the demise of the Soviet Union which was revealed as its paymaster all along.

12 October 1992, my sister saw the pressure burst the windows of the pub before the sound of the explosion which blew her clean across Long Acre. The bomb in the men's toilet of the Sussex Arms public house in Covent Garden killed one person and injured four others.

> *Every life is many days, day after day. We walk through ourselves, meeting robbers, ghosts, giants, old men, young men, wives, widows, brothers-in-love. But always meeting ourselves.*[49]

I know Belfast only by the enchantment of Astral Weeks. I have never been there.

'My tongue gets tied every every every every time I try to speak.' [50]

I was invited by an old friend from college to give a talk about my work at Hull School of Art. He was relatively new to teaching and I was a reluctant speaker. He was nervous for me and the feeling was contagious. The lecture theatre had a prodigious rake and a formal lectern. This was to be my first experience of stage fright. I would try to begin a sentence, personal pronoun followed by verb followed by a … by what? Each word became disconnected from myself and any ordering logic, each word seemed to land on the floor and stare back at me like those words that grow crazy if you think about them too much. Each word seemed too densely packed to own to anything but itself.

I remember that the students were agog.

A panic attack is a meeting with the absolute. The here and now are catastrophically present, suffocating any attempts at reflection with existential dread. I recognise this aphasia as a quintessential Naumanesque experience.

Do something or I'll die.

I can't do anything.

SPEAK AND DIE
SPEAK AND LIVE
FAIL AND DIE
FAIL AND LIVE

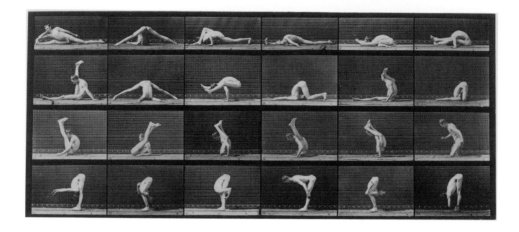

Edweard Muybridge, Man Performing
Contortions from *Animal Locomotion*, 1887

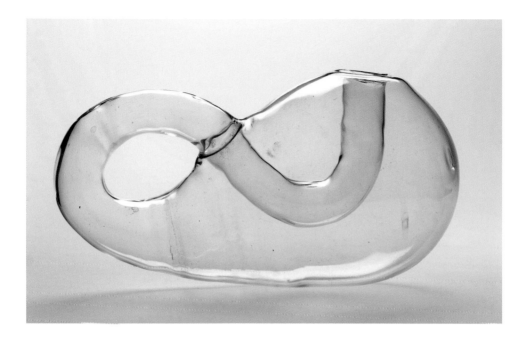

Francis Oakes, *Single glass Klein Bottle*, 1967

UN-

13. UN-

There is cruelty in Muybridge. When you examine the photos carefully you see that the grid before which a whole frieze of human presence and absence is played out is in fact like the peripheral fence at the end of a camp. The past is refracted through a future it could not fathom. Who sanctioned these actions? How were they persuaded or coerced into such un-human, inhumane activity?

The grid is a photographic negative of the Alberti screen which, since 1435, has served artists in their painstaking quest for verisimilitude in translating three dimensions into two. Muybridge's measure of time has become reified as the conquest of modular space – the grid, a key part of capitalism: from the one point perspective of the church and crown land to real estate, where the sky's the limit.

In the Green Zone you see the United Nations initials, black on white painted oil-cans. After a while I found I had started reading UN as UN-

The hyphen acts like a soothing balm to our sinful nature. Even if it never solved anything, even if redemption is a hangover from faith, we couldn't give it up.

What has been done cannot be un-done.

Joanna Kane, *Portrait of a Man:*
Samuel Taylor Coleridge, 1772–1834, 2007

Joanna Kane, *Portrait of a Man:*
William Wordsworth, 1770–1850, 2007

Once or twice he dictated a bit of Finnegans Wake *to Beckett, though dictation did not work very well for him; in the middle of one such session there was a knock at the door which Beckett didn't hear. Joyce said, 'Come in,' and Beckett wrote it down.*

Afterwards he read back what he had written and Joyce said, 'What's that "Come in"?' 'Yes, you said that,' said Beckett.

Joyce thought for a moment, then said, 'Let it stand.'[51]

Can't hear with the waters of. The chittering waters of. Flittering bats, fieldmice bawk talk. Ho! Are you not gone ahome? What Thom Malone? Can't hear with the bawk of bats, all thim liffeying waters of. Ho, talk save us! My foos won't moos. I feel as old as yonder elm. A tale told of Shaun or Shem? All Livia's daughtersons. Dark hawks hear us. Night! Night! My ho head halls. I feel as heavy as yonder stone. Tell me of John or Shaun? Who were Shem and Shaun the living sons and daughters of? Night now! Tell me, tell me, tell me, elm! Night night! Tellmetale of stem or stone. Beside the rivering waters of, hitherandthithering waters of. Night![52]

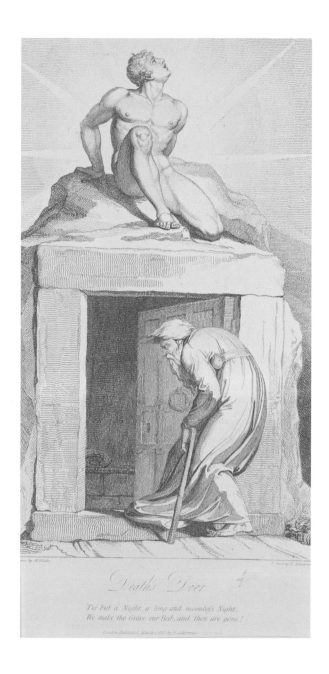

William Blake, *Death's Door* (Illustration to Blair's
The Grave) engraved by Luigi Schiavonetti, 1808

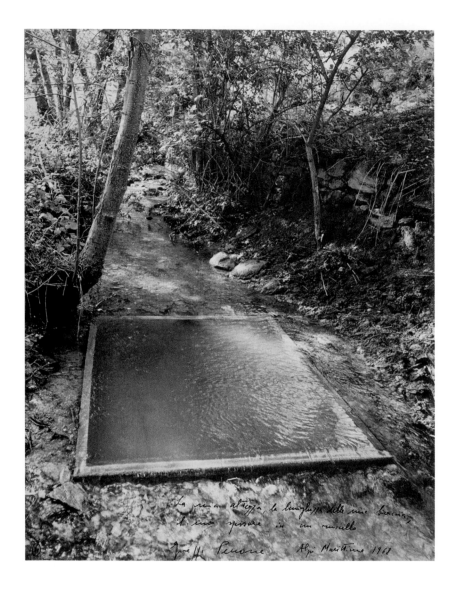

Giuseppe Penone, *Alpi maritime: my height, the length of my arms, my bredth in a brook*, 1968

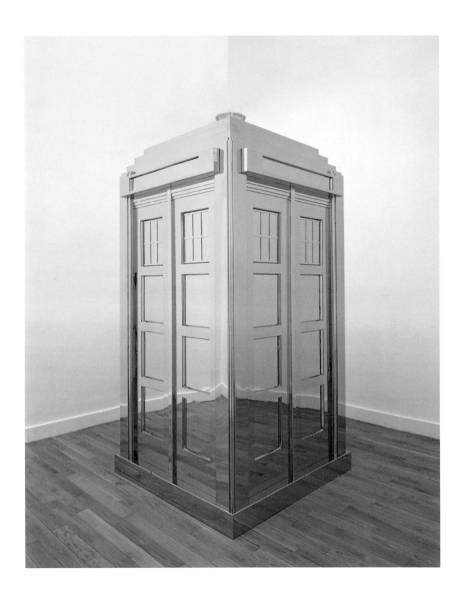

Mark Wallinger, *Time and Relative
Dimensions in Space*, 2001

Sturtevant, *Duchamp II rue Larrey*, 1992

14. The Un-Dead

The Dying Gaul. The Roman marble in the Capitoline Museum is a copy of an earlier Greek bronze, which no longer exists. The original was a cast, its simulacra a carving. The plaster version in Edinburgh College of Art is therefore a cast of a carving of a cast: an embodiment of completely divergent ways of creating a three-dimensional figure. And our relation to its pure white surface is further complicated by the fact that both the Greek and the Roman versions may have been painted.

The story of the sculpture shifts over time to conform to the demands of the Roman audience, transforming the stricken soldier into a wounded gladiator. It was widely copied, with kings, academics and wealthy landowners commissioning their own reproductions. The less wealthy could purchase copies of the statue in miniature to use as ornaments and paperweights. More basic, full-size plaster copies were also studied by art students.

The *écorché* in this pose was first cast in the late 18th century from the body of an executed smuggler and hence nicknamed 'Smugglerius'.

An *écorché* is a figure drawn, painted, or sculpted showing the muscles of the body without skin. The Renaissance architect and theorist Leon Battista Alberti recommended that when painters intend to depict a nude, they should first arrange the muscles and bones, then depict the overlying skin.

The Edinburgh cast supports his dying weight oblivious to his missing arm. The negative space we fill with feeling. *Einfuhlung.*

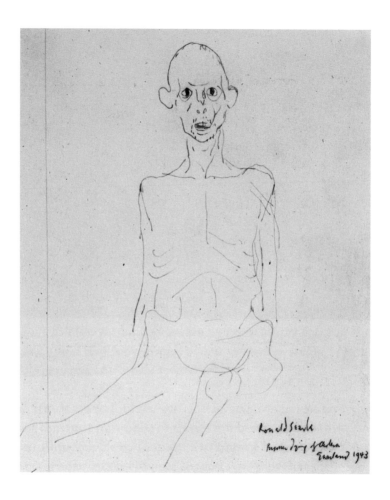

Ronald Searle, *Sick and Dying: Cholera – Thailand*, 1943

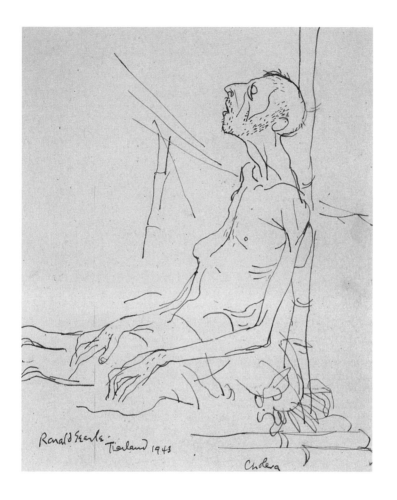

Ronald Searle, *Sick and Dying: Prisoner
Dying of Cholera, Thailand*, 1943

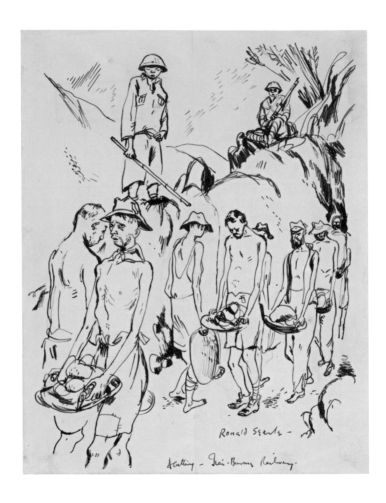

Ronald Searle, *In the jungle – working on a cutting.*
Rock clearing after blasting, 1943

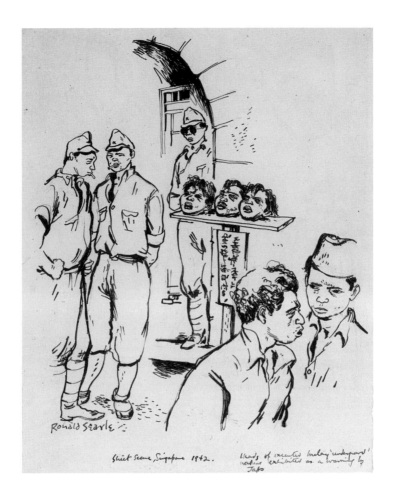

Ronald Searle, *Street scene, singapore 1942. Heads of executed Malay 'underground' workers exhibited as a warning*, 1945

Aernout Mik, *Raw Footage* (details), 2006

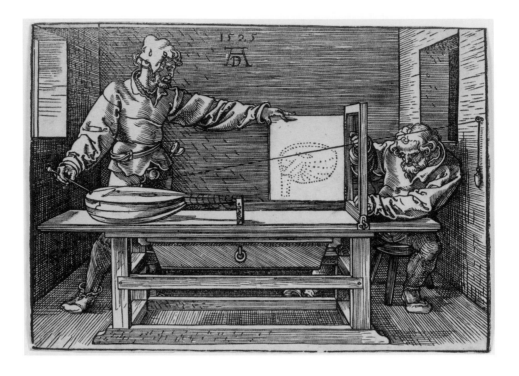

Albrecht Dürer, *Illustration to the Work on Measurement,
Showing an Interior* [Man Drawing a Lute], 1525

15. In An Ideal World

Why is the illusion of three dimensions so restful? Perhaps the modernist grid and the flat screen which we attend to each day mean that this extraordinary function of the mind's eye stimulates the full extent of our powers and gives us the magic of a shared hallucination. Perhaps it is the fact that we can conduct our own tour of this phenomenon. Ordinarily, sight is a thing of sheer presence: seeking, reacting, looking, staring, concentrated, oblivious. The stillness it describes is not the restless way we would interrogate a moment. The eye can only focus on one thing at time.

At a recent demonstration of 3-D imagery, at the very theatre where the Lumière Brothers first screened their films in London, David Burder takes us through a range of imagery. The audience is equipped with Polarising spectacles.

Twin carousel projectors give us the image of a peacock. We reach inside the frame and register its iridescent turquoise plumage, a function of our marvellous stereoscopy. The head-on image of Concorde has the nose projecting towards each spectator in turn, its degree of projection into the room governed by the distance of the viewer from the screen.

Thomas Demand, *Poll*, 2001

Cornelius Gijsbrechts, *The Reverse Side of a Painting*, 1670

Tacita Dean, *Foley Artist* (detail), 1996

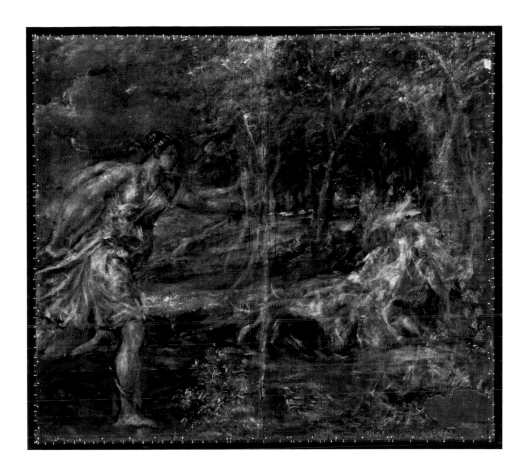

X-Radiograph of Titian's *The Death of Actaeon*, 1565–76

Mark Wallinger, *They think
it's all over ... it is now!*, 1988

16. Hamburg: 1989

They think it's all over ... it is now! (1988)

This work was made at a time when jingoism was rife in Thatcher's 'no-such-thing-as-society' England. The far right had appropriated the national flag. I had watched the 1966 World Cup Final in a hotel on the Isle of Wight and my sculpture reflected a kinder age: the last time that patriotism was viewed through innocent eyes. I hoped to evoke this lost world in this work.

It was exhibited in a large international exhibition curated by Harald Szeeman in Hamburg in November 1989.

Over and over again I heard the question: 'Is this the 3–2 goal?'

You'd think they'd let bygones be bygones.

During the installation I was on my way to the museum in a taxi when the driver ostentatiously turned up the volume on his radio. Chancellor Kohl was announcing the opening of the border between East and West Germany. Within half an hour we saw the first of what would be an invasion of Trabants, each containing three generations of the same family. Overnight, in this wealthy quarter of Hamburg, the BMWs were replaced by Trabants.

The reunited were given thirty marks spending money. Very early the next morning there was a large queue outside the main post office for the cash.

Mark Wallinger, *Oxymoron*, 1996

17. Home

We should never forget that of all the artistic forms, only the poem can be carried around in the brain perfectly intact. The poem, in a sense, is no more or less than a little machine for remembering itself: every device and trope whether rhyme or metre, metaphor or anaphora, or any one of the thousand others, can be said to have a mnemonic function in addition to its structural or musical one. Poetry is therefore primarily a commemorative act – one of committing worthwhile events and thoughts and stories to memory: poetry's elegiac tone is so universal and pervasive we've almost stopped hearing it.[59]

Courtyards in Delft

Oblique light on the trite, on brick and tile –
Immaculate masonry, and everywhere that
Water tap, that broom and wooden pail
To keep it so. House-proud, the wives
Of artisans pursue their thrifty lives
Among scrubbed yards, modest but adequate.
Foliage is sparse, and clings. No breeze
Ruffles the trim composure of those trees.

No spinet-playing emblematic of
The harmonies and disharmonies of love;
No lewd fish, no fruit, no wide-eyed bird
About to fly its cage while a virgin
Listens to her seducer, mars the chaste
Perfection of the thing and the thing made.
Nothing is random, nothing goes to waste.
We miss the dirty dog, the fiery gin.

That girl with her back to us who waits
For her man to come home for his tea
Will wait till the paint disintegrates
And ruined dikes admit the esurient sea;
Yet this is life too, and the cracked
Out-house door a verifiable fact
As vividly mnemonic as the sunlit
Railings that front the houses opposite.

I lived there as a boy and know the coal
Glittering in its shed, late-afternoon
Lambency informing the deal table,
The ceiling cradled in a radiant spoon.
I must be lying low in a room there,
A strange child with a taste for verse,
While my hard-nosed companions dream of fire
And sword upon parched veldt and fields of rain-swept gorse.

Derek Mahon[60]

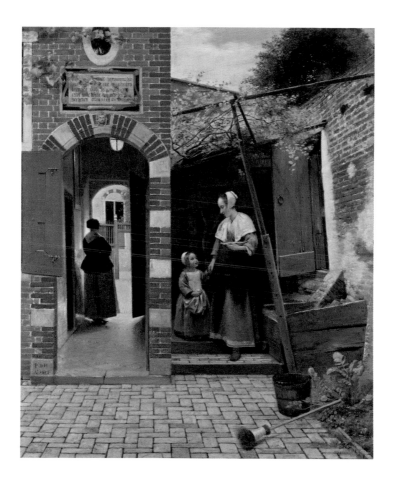

Pieter de Hooch, *The Courtyard
of a House in Delft*, 1658

Notes

All references to James Joyce's *Ulysses* are to the Penguin Modern Classics edition, 1969

1 James Joyce, *Ulysses* (first published in Paris, 1922). Chapter 15: Shouting out the name of Siegfried's sword Nothung in Wagner's opera, Stephen Dedalus enacts his own *Gotterdammerung* against the gaslight in a brothel.

2 James Joyce, *Finnegans Wake* (first published in London and New York, 1939), Chapter 1. The book's central theme is a cyclical pattern of fall and resurrection. Explaining this passage in his introduction to the Penguin Modern Classics edition (published in 2000), Seamus Deane writes: 'We are before history and yet within a history that has happened over and over. The hundred letter word, signifying the Fall, or a double Fall, since there is a war in heaven and a Luciferian Fall before there was a human Fall and war on earth, is a kind of molten Ur-language that will flow into the various mouldings of diverse languages, its noise formed into sounds and the sounds assuming to themselves the property of signification.'

3 Source: Catholic Encyclopaedia, www.newadvent.org

4 Philippe Petit wrote this as part of a memorial to the World Trade Center in a coda to his book *To Reach the Clouds* (London: Faber & Faber, 2002), an account of his historic walk between the Twin Towers.

5 The police officer sent to the scene later reported his experience: 'I observed the tightrope "dancer" – because you couldn't call him a "walker" – approximately halfway between the two towers. And upon seeing us he started to smile and laugh and he started going into a dancing routine on the high wire... Unbelievable really ... everybody was spellbound in the watching of it.'

6 Jean Baudrillard, *Simulations*, translated by Paul Foss, Paul Patton and Phil Beitchman, New York: Semiotext, 1983.

7 In *Ulysses*, Stephen Dedalus is represented as Icarus, son of Daedalus the wing-maker, the 'fabulous artificer'. These quotations appear in different parts of the book (pp. 510, 210 and 40).

8 The unnumbered 'chapters' of *Ulysses* roughly correspond to episodes of Homer's

Odyssey. Chapter 3 is known as the 'Proteus' episode, and refers to the sea god Proteus, who could change forms at will. In this section, Stephen Dedalus, whose glasses are broken and who cannot see clearly, soliloquises silently as he idles on the beach.

9 Source: Edward A. Kopper, *CliffsNotes on Ulysses*, www.cliffsnotes.com. The first paragraph of the Proteus chapter questions whether what we see is real; the second paragraph goes on to question the reality of the audible, as Stephen closes his eyes 'to hear'.

10 Bloomsday is celebrated annually on 16 June, the date of Leopold Bloom's day-long odyssey in *Ulysses*. 16 June 1904 was also the day on which James Joyce first stepped out with Norah Barnacle, who later became his wife.

11 James Joyce, *Ulysses*, chapter 12 ('Cyclops' episode). In a pub, a man – an ultra-nationalist called 'the Citizen' – taunts Bloom with anti-Semitic remarks and finally hurls a biscuit tin at him. In his stupidity and blind prejudice, the Citizen parallels the *Odyssey's* Cyclops, a one-eyed giant.

12 James Joyce, *Ulysses*, chapter 12 ('Cyclops' episode).

13 James Joyce, *Ulysses*, chapter 4 ('Calypso' episode).

14 Michael Hamburger, *A Mug's Game – Intermittent Memoirs – 1924-1954*, Manchester: Carcanet Press, 1973

15 Founded in 1911 in Potsdam, Studio Babelsberg is the oldest large-scale film studio in the world. Hundreds of films were made there before World War II, including silent movies such as *Nosferatu* and *The Cabinet of Dr. Caligari*, together with later classics such as Fritz Lang's *Metropolis* (which bankrupted it) and *The Blue Angel*. Babelsberg still functions as a thriving film and TV studio today.

16 '*The Singing Ringing Tree*, made in a fully imagined world in Babelsberg, tells the story of a selfish princess who sends a long-suffering prince on a quest for a magical tree. He reaches the border of another kingdom which is protected by a ravine and a sheer rock face and guarded by a dwarf. The prince explains his quest for the magical tree, and the dwarf offers it to him on one condition. If the princess does

not love him by sunset, he must return to live in the magic kingdom. The prince is so confident that he jokes. He says that if he fails he will be turned into a bear...' Mark Wallinger, 'Sleeper', text for *Frieze*, May 2005.

17 After the Berlin Wall was built, Potsdam was cut off both from its neighbour West Berlin, and from East Berlin. The Glienicke Bridge between Potsdam and West Berlin served as a border crossing and became an important landmark in Cold War espionage.

18 Mark Wallinger's film *Sleeper* (2004–05) is the record of the ten nights that he spent alone in Berlin's Neue Nationalgalerie in 2004. Mies van der Rohe's famously minimalist glass and steel building is more like a vast shop window than a conventional art gallery and at night Wallinger, dressed as a bear (the city's emblem), was highly visible. His point was that Berlin, once the epicentre of the Cold War, was a place where spies could blend into their surroundings by taking on disguises. As he recalls, 'It was cold and dark outside. I viewed my incarceration with anxiety, mainly over a boredom that never descended. But I was a highbrow bear – I had gone out and bought the Naxos unabridged reading of *Ulysses* which I planned to listen to under my disguise.'

19 Mark Wallinger, 'Sleeper', text for *Frieze*, May 2005.

20 Ibid.

21 Lucia Joyce (1907-1982) started to show signs of mental illness in 1930. She became a patient of Jung's in 1934 and shortly after this was diagnosed with schizophrenia. From 1951 until her death, she was a patient at St Andrew's Mental Hospital in Moulton Park, Northampton.

22 James Joyce, *Finnegans Wake*, p. 115.

23 James Joyce's 'epiphanies' are a series of brief, early prose works derived from fragments of overheard dialogue or personal meditation. In *Stephen Hero*, the early, abandoned, version of *A Portrait of the Artist as a Young Man*, Joyce's protagonist offered this definition of what Joyce himself had come to see as moments of artistic radiance: 'By an epiphany he [Stephen Dedalus] meant a sudden spiritual manifestation, whether in the vulgarity of speech or of gesture or in a memorable phase of the mind itself. He believed that it was for the man of letters to record these epiphanies with extreme care, seeing that they themselves are the most delicate and evanescent of moments.'

24 Freud wrote that many features of dreams were usually 'overdetermined', in that they were caused by multiple factors in the life of the dreamer, from the 'residue of the day' (superficial memories of recent life) to 'potent thoughts' (deeply repressed traumas and unconscious wishes). Freud favoured interpretations which accounted for such features not once but many times, in the context of various levels and complexes of the dreamer's psyche.

25 *Quidditas*, a Latin legal term meaning 'the essential nature of a thing'.

26 Anna Funder, *Stasiland: Stories from behind the Berlin Wall*, London: Granta, 2003. Chapter 3, 'Bornholmer Bridge', is about Miriam Weber who, as a sixteen year old, nearly succeeded in scaling the Berlin Wall.

27 'Hagen Koch was twenty-one years old, and he was Secretary-General Honecker's personal cartographer. Unlike most heads of state, Honecker needed a cartographer, because he was redrawing the limits of the free world.' André Stitt, www.navigatelive.org

28 The Berlin Wall was erected along the demarcation between the eastern sector of Berlin controlled by the Soviet Union, and the western sectors occupied by the United States, France, and Great Britain. The Israeli West Bank barrier is located mainly within the West Bank, partly along the 1949 Armistice line, or 'Green Line' between Israel and Jordan.

29 The 'Wailing Wall' forms part of the western flank of Temple Mount. This vast man-made platform is sacred to both Jews and Muslims and is one of the world's most contested religious sites. Built around the site of Solomon's Temple, the compound was the location of the Second Temple which, until its destruction by the Romans in 70CE, was the centre of Jewish worship. Temple Mount, known to Muslims as the Noble Sanctuary, is now the site of the Dome of the Rock. Completed in 691CE, this shrine is the oldest extant Islamic building in the world.

30 The 'blood libel' against Jews was an allegation, repeated at intervals from the thirteenth to the sixteenth centuries, that Jews were killing Christian children to use their blood for the ritual of making unleavened bread (matzoh). The most famous golem – an animated being created from inanimate matter – is that of Rabbi Yehuda Leow, the famous Maharal of Prague, who created a golem to protect the Jewish community from harm and, after using him to prevent a blood libel, hid him in the attic of the synagogue. According to legend, the golem is still there, having miraculously escaped the destruction of the ghetto by the Nazis.

31 Christopher Middleton (ed.), *Johann Wolfgang von Goethe, Selected Poems*, London: John Calder, 1982. In Greek mythology, Prometheus is the creative artist who fashioned humans out of clay. Wallinger has described Prometheus as both 'creator' and 'destroyer', who is 'condemned for playing God'. He relates the Prometheus figure to the scientist Victor Frankenstein in Mary Shelley's novel *Frankenstein: or, The Modern Prometheus* (1818), in which the creator is ultimately destroyed by his own monstrous creation.

32 Goethe, 'Hegira', 1814, v.1, trans. Michael Hamburger in Christopher Middleton (ed.), *Johann Wolfgang von Goethe, Selected Poems*, London: John Calder, 1982.

33 Omar Khayyam (1048-1123), *Rubayyat*, verse 1, trans. Edward Fitzgerald, 1859.

34 John Keats, 'Ode to a Nightingale,' 1819.

35 Painted in 1602, Caravaggio's *The Taking of Christ* disappeared in the eighteenth century. It was rediscovered in Dublin in 1990 and is now on long loan to the National Gallery of Ireland. The painting is reproduced on http://en.wikipedia.org/wiki/File:Takingofchrist.jpg

36 During the second phase of the Turkish invasion in August 1974, the Turkish army took the city of Famagusta. The tourist quarter was completely sealed off immediately after being captured and no one was allowed to enter. It still remains exactly as it was then. Three years after the invasion, a Swedish journalist reported that 'the breakfast tables are still set, the laundry still hanging and the lamps still burning'.

37 Cyprus entered the British Empire under rather unusual circumstances in 1878, during the Russo-Turkish war. Realising that a victory by Russia would directly threaten British access to the newly built Suez Canal, Great Britain, in agreement with Turkey, took control of Cyprus, effectively 'renting' the island for an annual payment of around £92,000.

38 *The Daily Telegraph*, 24 August, 2002.

39 'Fay knights' is a form of *fains* or *fainites*, truce terms used for respite during playground games which date back to medieval England.

40 Yve-Alain Bois, 'A Drawing That is Habitable', in *Fred Sandback*, Ostfildern-Ruit: Hatje Cantz Verlag, 2005. Bois quotes from Valérie Mavridorakis, *Fred Sandback ou le fil d'Occam*, Brussels: Le Lettre volée, 1998.

41 Definition from Wikipedia, www.wikipedia.org

42 Rudolf Nureyev, *Nureyev, an Autobiography with Pictures*, London: Dutton, 1963.

43 Ibid.

44 Meredith Daneman, *Margot Fonteyn: A Life*, London: Penguin, 2005.

45 Rudolph Nureyev was born on the Trans-Siberian train while his mother was travelling to Vladivostok, where his Red Army commissar father was stationed. Twenty-three years later, on 16 June 1961, he defected from the Soviet Union at the Le Bourget Airport in Paris. Within a week of his defection, he was signed up by the Grand Ballet du Marquis de Cuevas and was performing *The Sleeping Beauty* with Nina Vyroubova.

46 Stuart Cloete, *How Young They Died*, (1969), quoted in Paul Fussell, *The Great War and Modern Memory*, Oxford: Oxford University Press, 1975, with this preface: 'Countless wounded soldiers recall dividing into actor and audience, at moments of the highest emergency. Stuart Cloete's "Jim Hilton", wounded in the shoulder, makes his way to the rear thus:'

47 www.brokenprojector.com: 'The Vertigo Zoom or How I learned to fall into an infinite abyss while standing perfectly still'. 27 August 2007 by Gautam.

48 Official newspaper of Sinn Féin.

49 James Joyce, *Ulysses*, p. 213.

50 Van Morrison's folk-jazz classic, recorded in 1968.

51 Richard Ellmann, *James Joyce (Oxford Lives)*, Oxford: Oxford Paperbacks, 1984.

52 James Joyce, *Finnegan's Wake*.

53 'In 1859 Sir Charles Eastlake, director of the National Gallery and one of the most discerning connoisseurs in Europe, went to Madrid to look at the availability of Spanish paintings. In 1865, Eastlake was in Paris bidding on behalf of the National Gallery for two paintings by Velázquez. The first was at the sale of one of the most admired collections in Paris, that of Count James-Alexandre de Poutalès-Gorgier. Among its contents was a picture known as the *Dead Roland* or *Dead Soldier*, showing the corpse of a youthful warrior in black silk, lying surrounded by skulls. Edouard Manet had been deeply affected by this painting a few years earlier, although he may only have seen a print, and had based his *Dead Matador* on it (1863–4, National Gallery of Art, Washington). Because of the painting's restricted palette, macabre realism and startling composition, it was thought to be by Velázquez, and Eastlake, convinced by the attribution, bid more than £1500 for it. The attribution to Velázquez, however, did not survive the test of time. Today the painting is catalogued as by an unknown artist.' Xavier Bray, 'Velázquez and Britain' in *Velázquez*, National Gallery, 2006.

54 In *vanitas* still lifes, the objects are emblematic of the brevity of life and the vanity of human achievement. Common *vanitas* symbols include skulls, which are a reminder of the certainty of death, bubbles which symbolise life's brevity, and snuffed-out candles and smoke which signify the ephemeral nature of life.

55 Miriam Milman, *Trompe l'Oeil Painting: The Illusions of Reality*, London: Macmillan, 1983.

56 Vija Celmins's sculpture *To Fix The Image In Memory* (illustrated on p.41) is a sort of double *trompe l'oeil*: an actual stone shown side by side with its bronze double, cast and painted in exact resemblance of the original. Celmins describes the work as 'an exercise in looking',

and goes on to say: 'in the case of the bronze stones, I wanted to see how much I could see … to test my seeing and making, as if there were some secret to be discovered only there. I left the original for the viewer to relive that process of seeing. Of course, on close inspection, one sees that the "made" piece is invented – an interpretation.' ('Vija Celmins interviewed by Chuck Close', in *Vija Celmins*, New York: A.R.T. Press, 1992).

57 The Renaissance architect Filippo Brunelleschi (1377-1446) pioneered the scientific use of perspective. Around 1415, he made the first known perspective picture. Describing this famous experiment, his biographer Antonio di Tuccio Manetti, wrote: 'The hole was as tiny as a lentil bean on the painted side and it widened conically like a woman's straw hat to about the circumference of a ducat, or a bit more, on the reverse side. He required that whoever wanted to look at it place his eye on the reverse side where the hole was large, and while bringing the hole up to his eye with one hand, to hold a flat mirror with the other hand in such a way that the painting would be reflected in it. The mirror was extended by the other hand a distance that more or less approximated in small braccia the distance in regular braccia from the place he appears to have been when he painted it up to the church of San Giovanni. With … the viewpoint, etc., the spectator felt he saw the actual scene when he looked at the painting. I have had it in my hands and seen it many times in my days and can testify to it.'

58 Erasmus: 'In the land of the blind the one-eyed man is king'.

59 Don Paterson, *101 Sonnets*, London: Faber and Faber, 2002.

60 Derek Mahon, *Selected Poems*, London: Penguin, 2006.

Afterword

The Russian Linesman: Frontiers, Borders and Thresholds is the latest
in a series of Hayward Touring exhibitions curated by artists.[1]
These projects can open up new and unexpected approaches to
exhibition making as well as giving special insights into the artist's
own deeper preoccupations. There is no predetermined agenda and
the artist has a relatively free hand to explore whatever territory
interests them, in contemporary art or art history.

Mark Wallinger is one of Britain's most intellectually curious and
unpredictable artists, passionately engaged with politics, literature,
history, sport and popular culture. His practice ranges freely
across media, each work taking the form appropriate to the idea,
whether in video, painting, photography, sculpture or installation.
The Russian Linesman is similarly heterogeneous, embracing
classical and minimalist sculpture, 17th century painting, Victorian
photography, Renaissance prints, stereoscopic images, video
and installation. The exhibition's interrelated themes reflect his
concerns as an artist: ambiguities of perception and the unstable
relation between knowledge and experience, fact and fiction,
reality and illusion. The concept of the liminal has been central to
the artist's conception of this show. Associated with transitional
states characterised by indeterminacy, it can signify the dissolution
of boundaries and fixed identities.

1 Artists who have curated past exhibitions include Michael Craig-Martin, *Drawing the Line*;
Richard Wentworth, *Thinking Aloud*; Susan Hiller, *Dream Machines*; and Tacita Dean, *An Aside*.

A recent work of Wallinger's, *Self Portrait* (2008), consists of large painted variations on the capital letter 'I', each in a different printer's font: from Copperplate Gothic Bold, Shortened, to Engravers MT, to Wide Latin to Freehand. The Freehand 'I' is tilted slightly, with wavering edges, and is oddly reminiscent of the shambling figure of the artist dressed as bear (*Sleeper*, 2005) restlessly pacing a deserted citadel of modern art, the Neue Nationalgalerie in Berlin, on ten successive nights in 2004. The idea of multiple personae, the artist assuming a guise and disappearing into his subject, is apt in this context. The solution to the problem of identity, suggested the American critic Norman O. Brown, is to get lost. Mark Wallinger's play with his identity in many of his own works is echoed in *The Russian Linesman*, with its multiplicity of themes, cross-references, visual rhymes and associations of ideas. The artist is fascinated by the ways in which the individual's subjective consciousness is immersed in – and participates in – the wider collective consciousness, how we negotiate the many levels of phenomena experienced in daily life, shifting between the personal, the practical, the social and the poetic. What we know of ourselves includes everything that we know of the world. James Joyce's all-encompassing representation of consciousness in *Ulysses*, his appropriation of many styles and voices, is a crucial inspiration

After its Hayward showing, the exhibition will tour to Leeds Art Gallery and the Glynn Vivian Art Gallery, Swansea, both of which have past connections with the artist: Leeds owns a major work, *Threshold to the Kingdom*, and Swansea showed *Ecce Homo* and *Threshold* in 2002. We thank Nigel Walsh and Tanja Pirsig-Marshall at Leeds and Jenni Spencer-Davies and Karen McKinnon in Swansea for their wholehearted commitment to the show from its inception.

We also thank the following lenders and others who have made the exhibition possible:

Public Institutions: The British Museum: Charles Collinson, Antony Griffiths, Philippa Kirkham, Mark McDonald; Edinburgh College of Art: Dr. Clementine Deliss, Margaret Stewart, Ruxandra-Iulia Stoica, Michael Wood; The Fitzwilliam Museum, Cambridge: Dr. Lucilla Burn, David Scrace, Thyrza Smith; Imperial War Museum, London: Ulrike Smalley, Jenny Wood; Magdalen College, Oxford: Jane Eagan, Dr. Christine Ferdinand, Dr. Robin Darwall-Smith; The National Gallery, London: Naomi Aplin, Dr. Xavier Bray, Margaret Daly, Dr. David Jaffe, Dr Nicholas Penny; Royal Academy of Arts, London: Rachel Hewitt, Edwina Mulvany; Science Museum, London: Christopher Higgins, Maria Rollo, Dr. Jane Wess; Tate, London: Catherine Clement, Caroline Collier, Pip Laurenson, Tina Weidner; UCL Library Special Collections, London: Susan Stead; Victoria and Albert Museum: Martin Barnes, Juliet Ceresole, Victoria Jarvis, Roxanne Peters, Marta Weiss; Yale Centre for British Art, New Haven: Melissa Fournier, Timothy Goodhue.

Private Collections and Galleries: Anthony Reynolds Gallery, London: Anthony Reynolds, Maria Stathi; Carlier/Gebauer, Berlin: Daniel Carlier, Philipp Selzer; The Dulverton Trust: Colonel Christopher Bates; Electronic Arts Imtermix, New York: Ann Adachi, Rebecca Cleman; The Estate of Fred Sandback: David Gray, Amavong Panya, Amy Baker Sandback; Frith Street Gallery, London: Dale McFarland; Marian Goodman Gallery, New York: Brian Loftus, Leslie Nolen; McKee Gallery, New York: Anders Bergstrom, David McKee; NBC News Archives: Jeremy Hunt; Monika Sprüth Philomene Magers, London: Andrew Silewicz; Zwirner & Wirth, New York: Greg Lulay, Lauren Knighton.

And also: Chris Beetles, David Burder, Rachel Calder, Simeon Corless, James Doyle, Sandro Grando, Rachel Holmes, Karen Holmes, Jenni Lomax, Marcus Risdell, Jorma Saarikko.

List of Works

All measurements are in centimetres,
width x height x depth

* Denotes Hayward showing only

Page 103
Anon, Italian
A Dead Soldier, 17th Century
Oil on canvas
104.8 x 167
© The National Gallery, London

Page 64
Anon
*Double Headed Herm, with Heads of
Dionysos and Bearded Silenus*, Early
Roman
Marble sculpture
38 x 20 x 20
The Fitzwilliam Museum, Cambridge
Reproduced by permission of the
Syndics of The Fitzwilliam Museum,
Cambridge
© The Fitzwilliam Museum, Cambridge

Page 100
Anon
Dying Gaul, 1822
Plaster cast of the marble copy
(Capitoline Museum, Rome) of an
original bronze Hellenistic sculpture
140 x 184.5
On loan from the Governors of
Edinburgh College of Art
Photo: John McGregor, eca photographer

Page 69
Anon
*Indian Encampment at Fort Colville,
photographed by a Royal Engineers
photographer on a US-Canada Border
Survey*, 1860–1
Albumen print
21.3 x 26.7
Victoria & Albert Museum
© V&A Images/Victoria &
Albert Museum

Page 69
Anon
*Linyakwateen Depot Camp, on the
Left Bank of the Pend d'Oreille River,
photographed by a Royal Engineers
photographer on a US-Canada Border
Survey*, 1860–1
Albumen print
22.5 x 26.2
Victoria & Albert Museum
© V&A Images/Victoria &
Albert Museum

Anon
*Obelisk on 49th Parallel on Western
Face Point Roberts at Western Terminus
of the Continental Boundary East Face,
photographed by a Royal Engineers
photographer on a US-Canada Border
Survey*, 1860–1
Albumen print
17.6 x 14
Courtesy Victoria & Albert Museum
© V&A Images/Victoria &
Albert Museum

Page 69
Anon
*Parallel on the Right Bank of the River
Looking West, photographed by a Royal
Engineers photographer on a US-Canada
Border Survey*, 1860–1
Albumen print
24.5 x 22.4
Courtesy Victoria & Albert Museum
© V&A Images/Victoria &
Albert Museum

Page 68
Anon
*Stone Pyramid on the 49th Parallel, on
the Right Bank of the Eastern Intersection
of the Kootenay River, Cutting on the Left
Bank, photographed by a Royal Engineers
photographer on a US-Canada Border
Survey*, 1860–1
Albumen print
22.5 x 26.7
Victoria & Albert Museum
© V&A Images/Victoria & Albert
Museum

Anon
*Stone Pyramid and Cutting, Kisenehn,
photographed by a Royal Engineers
photographer on a US-Canada Border
Survey*, 1860–1
Albumen print
22 x 27.5
Courtesy Victoria & Albert Museum
© V&A Images/Victoria &
Albert Museum

Anon
Combat in the West, *Carrier pigeons
transported in a bearer frame*, 1940
Stereoscopic photograph
Raumbild-Verlag Otto Schönstein K.G.
Courtesy of David Burder

Anon
German Sculpture of Our Times, *View
in the workshop of Professor Thorak – In
the background a sculpture for the model of
Märzfeld in Parteitaggelände Nuremburg.
In the foreground the goddess of victory.
Sculptor Josef Thorak*, 1942
Stereoscopic photograph
Raumbild-Verlag Otto Schönstein K.G.
Courtesy of David Burder

Anon
German Sculpture of Our Times, *Bust
of the Führer. Bronze, height 90 cm. Made
in 1939. Sculptor Ferdinand Liebermann*,
1942
Stereoscopic photograph
Raumbild-Verlag Otto Schönstein K.G.
Courtesy of David Burder

Anon
The Führer's Soldiers in the Fields,
*German and Russian boundary post at the
line of demarcation*, 1939
Stereoscopic photograph
Raumbild-Verlag Otto Schönstein K.G.
Courtesy of David Burder

Anon
The Führer's Soldiers in the Fields,
Russian boundary post, 1939
Stereoscopic photograph
Raumbild-Verlag Otto Schönstein K.G.
Courtesy of David Burder

Anon
The Holy Land, *Old temple area is now
Moslem shrine*, c. 1960s
Stereoscopic photograph
View-Master reel no. B2263
Courtesy of David Burder

Anon
The Holy Land, *Palm Sunday procession
from Mount of Olives*, c. 1960s
Stereoscopic photograph
View-Master reel no. B2263
Courtesy of David Burder

Anon
The Holy Land, *Cattle Market Day, in
the Lower Pool or Gihon, Valley of Hinnom,
Jerusalem*, c. 1990
Stereoscopic photograph
Underwood & Underwood
Courtesy of David Burder

Anon
The Olympic Games, *Berlin: Guest of
honour*, 1936
Stereoscopic photograph
Raumbild-Verlag Otto Schönstein K.G.
Courtesy of David Burder

Page 116
Anon
Queen Elizabeth II visits her people
in Nigeria II, *Her Majesty at Itu Leper
Colony*, 1956
Stereoscopic photograph
View-Master reel no. 3765-C
Courtesy of David Burder

Anon
Queen Elizabeth II visits her people in
Nigeria II, *Her Majesty in the East*, 1956
Stereoscopic photograph
View-Master reel no. 3765-C
Courtesy of David Burder

Ernest Eugène Appert
A Firing Squad, Paris Commune, 1871
Albumen print from collodion negative
10.8 x 16.3
Victoria & Albert Museum
© V&A Images/Victoria &
Albert Museum

Felice Beato
The Sphynx, Egypt, late 19th Century
Albumen print from collodion negative
23.8 x 28.8
Courtesy Victoria & Albert Museum
© V&A Images/Victoria &
Albert Museum

Pages 74–75
Jérôme Bel
Véronique Doisneau, 2005
Recorded at the Palais Garnier: Paris
National Opera DVD, sound, colour,
37 minutes
© France 2005 – Paris National Opera –
Telmondis
Photo credits: far right © Icare; far left,
left, right © Anna Van Kooij

Page 65
Renato Giuseppe Bertelli
Profilo Continuo (Testa di Mussolini)
[Continuous Profile (Head Of Mussolini)],
1933
Terracotta with black glaze
34 x 28 x 28
Imperial War Museum
© The Estate of Renato Giuseppe Bertelli

Page 10
Joseph Beuys
Cosmos and Damien Polished, 1975
Hand-coloured lithograph on paper
33 x 23
Tate, London
© DACS / Tate, London 2008

Page 95
William Blake
Death's Door, (Illustration to Blair's
The Grave) engraved by Luigi
Schiavonetti, 1808
Etching
27.90 x 13.40
The British Museum
© Trustees of The British Museum

Page 39
William Blake
Jerusalem: The Emanation of the Giant
Albion, 1804–1821
Relief Etching, printed in very dark
green ink; black ink and grey wash
applied with brush
22.20 x 16.20
The British Museum
© Trustees of The British Museum

Page 40
Louis Léopold Boilly
Ivory Crucifix Hanging on a Wall, 1812
Oil on Canvas
61 x 48.3
The Dulverton Trust, on loan to
Magdalen College, Oxford
© The Dulverton Trust

Page 47
Richard Carline
Jerusalem and the Dead Sea from an
Aeroplane, 1919
Oil on canvas
105.4 x 130.8
Imperial War Museum
© Imperial War Museum

Page 41
* Vija Celmins
To Fix The Image In Memory XII, 1977–82
Stone and painted bronze
11.4 x 8.9 x 10.2
Mckee Gallery, New York
© Vija Celmins 2009

Page 114
* Tacita Dean
Foley Artist, 1996
Single monitor installation, colour
video, with playback machine, eight
speakers and dubbing chart in lightbox
Dimensions variable
Collection Tate, London
Courtesy the artist, Frith Street Gallery,
London and Marian Goodman Gallery,
New York and Paris
© the artist 2008

Page 112
Thomas Demand
Poll, 2001
C-Print and diasec
180 x 260
Courtesy the artist and Monika Sprüth
Philomene Magers, London/Berlin
© DACS 2008

Page 30
Albrecht Dürer
Apocalypse, c.1498
Woodcut
39.50 x 28.7
The British Museum
© Trustees of The British Museum

* Albrecht Dürer
Book on Proportion, 1525
Woodcut and letterpress
45 x 33.5
Courtesy The British Museum
© Trustees of the British Museum

Page 110
Albrecht Dürer
*Illustration to the Work on Measurement,
Showing an Interior*, 1525
Woodcut
13.20 x 18.50
The British Museum
© Trustees of the British Museum

Albrecht Dürer
*Illustration to the Work on Measurement,
Showing the Interior of a Bedchamber*, 1525
Woodcut
13.20 x 18.50
The British Museum
© Trustees of the British Museum

Page 2
Roger Fenton
The Skeletons of a Man and a Male Gorilla,
c. 1854–58
Sepia photograph
36.9cm x 28.4
The British Museum
© Trustees of the British Museum

Frank Good
Second Pyramid, Gizeh, 1872
Albumen print
15.9 x 19.7
Victoria & Albert Museum
© V&A Images/Victoria &
Albert Museum

Page 63
Frank Good
Brick Pyramids, Israelitish, 1872
Albumen print
158 x 208
Victoria & Albert Museum
© V&A Images/Victoria &
Albert Museum

Frank Good
Pyramids, Sakkara, 1868
Albumen print from collodion negative
16 x 20.8
Victoria & Albert Museum
© V&A Images/Victoria &
Albert Museum

Page 44
Frank Good
View of Jerusalem, 1866–67
Albumen print from collodion negative
15.4 x 20.7
Victoria & Albert Museum
© V&A Images/Victoria &
Albert Museum

Page 45
Frank Good
Wailing Wall, Jerusalem, 1866–67
Albumen print from collodion negative
154 x 207
Victoria & Albert Museum
© V&A Images/Victoria &
Albert Museum

Page 54
Linda Herzog
Lake Van, Turkey, 2006
Inkjet on baryta paper
102 x 126
Courtesy the artist
© Linda Herzog 2009

Page 80
Robert Hooke
Drawing of a Flea From '*Micrographia:
or some physiological descriptions of minute
bodies made by magnifying glasses. With
observations and inquiries thereupon*', 1665
Engraving
46 x 32
UCL Library Speical Collections
Photo courtesy: The Royal Society
© The Royal Society

James Joyce
'Anna Livia Plurabelle' from *Finnegans
Wake*
Read by James Joyce, c.1932
Audio, 8 mins 32 seconds
© HarperCollins

Joanna Kane
Portrait of a Man: John Keats, 1795–1821,
2007
C -Type digital photograph
84 x 59.4
Courtesy of the artist
© the artist 2009

Page 92
Joanna Kane
*Portrait of a Man: Samuel Taylor Coleridge,
1772–1834*, 2007
C -Type digital photograph
84 x 59.4
Courtesy of the artist
© the artist 2009

Joanna Kane
*Portrait of a Man: William Blake,
1757–1827*, 2007
C -Type digital photograph
84 x 59.4
Courtesy of the artist
© the artist 2009

Page 93
Joanna Kane
*Portrait of a Man: William Wordsworth,
1770–1850*, 2007
C -Type digital photograph
84 x 59.4
Courtesy of the artist
© the artist 2009

Page 108–9
* Aernout Mik
Raw Footage, 2006
DVD, colour, sound, 74 mins
Courtesy carlier | gebauer
© carlier | gebauer and the artist 2008

Edweard Muybridge
Birds Being Shot from *Animal
Locomotion*, 1887
Collotype
13 x 46
Victoria & Albert Museum
© V&A Images/Victoria & Albert
Museum

Page 72
Edweard Muybridge
Bird in Flight from *Animal Locomotion*,
1887
Collotype
13 x 46
Victoria & Albert Museum
© V&A Images/Victoria & Albert
Museum

Edweard Muybridge
Man Diving Forwards from *Animal
Locomotion*, 1887
Collotype
13 x 46
Victoria & Albert Museum
© V&A Images/Victoria &
Albert Museum

Edweard Muybridge
Man Performing Acrobatics from
Animal Locomotion, 1887
Collotype
13 x 46
Victoria & Albert Museum
© V&A Images/Victoria &
Albert Museum

Page 88
Edweard Muybridge
Man Performing Contortions from
Animal Locomotion, 1887
Collotype
13 x 46
Courtesy Victoria & Albert Museum
© V&A Images/Victoria &
Albert Museum

Page 88
Edweard Muybridge
Man Performing Contortions Part 2
from *Animal Locomotion*, 1887
Collotype
13 x 46
Victoria & Albert Museum
© V&A Images/Victoria &
Albert Museum

Page 83
Edweard Muybridge
Man Walking and Throwing a Discus
from *Animal Locomotion*, 1887
Collotype
13 x 46
Victoria & Albert Museum
© V&A Images/Victoria &
Albert Museum

Page 82
Edweard Muybridge
Woman Crouching from *Animal
Locomotion*, 1887
Collotype
13 x 46
Victoria & Albert Museum
© V&A Images/Victoria &
Albert Museum

Page 78
Bruce Nauman
Revolving Upside Down, 1969
Video, black and white, sound, 61 mins
Courtesy Electronic Arts Intermix (EAI),
New York
© ARC, NY and DACS, London 2009

Page 36
C.R.W. Nevinson
The Road From Arras To Bapaume, 1917
Oil on canvas
60.9 x 45.7
Imperial War Museum
© Imperial War Museum

Page 89
Francis Oakes
Single glass Klein bottle, 1967
Glass
13 x 24.5 x 13
The Science Museum/Science and
Society Picture Library
© Science Museum/Science and
Society Picture Library

Page 96
Giuseppe Penone
Alpi Maritime (1–6), 1968
Set of 6 black and white photographs
66.3 x 51.7
Courtesy Marian Goodman Gallery,
New York
© ADAGP, Paris and DACS, London 2009

*The French high wire artist, Philippe Petit,
walks across a tightrope suspended between
The World Trade Center's Twin Towers,
New York*, 1974
DVD, sound, colour, 3mins 34 secs
© NBC News Archives

Page 101
William Pink after Agostino Carlini, RA
*Smugglerius (Écorché of Man in the Pose of
the 'Dying Gaul')*, 1834
Plaster cast on wooden support
76.5 x 161 x 70
Royal Academy of Arts, London
© Royal Academy of Arts, London
Photo: Paul Highnam

* Fred Sandback
Untitled (Right-angled Construction), 1987
Dark red acrylic yarn
Dimensions vary with each installation
© Estate of Fred Sandback
Photo credit: photography by Cathy
Carver. Courtesy Zwirner & Wirth, New
York. Image © Zwirner & Wirth 2007

Fred Sandback
*Untitled (Sculptural Study, Triangular
Cornered Construction)*, ca. 1988/2006
Yellow and light green acrylic yarn
268.6 x 256.5 x 256.5
© Estate of Fred Sandback
Photo credit: photography by Cathy
Carver. Courtesy Zwirner & Wirth, New
York. Image © Zwirner & Wirth 2007

Page 57
* Fred Sandback
*Untitled (Three-part High-relief
Construction)*, 1999
Black acrylic yarn
Height and width vary with each
installation, 35.6 deep
© Estate of Fred Sandback
Photo credit: photography by Cathy
Carver. Courtesy Zwirner & Wirth, New
York. Image © Zwirner & Wirth 2007

Page 58
Bojan Šarčević
It seems that an animal is in the world as water in water, 1999
DVD, colour, sound, 7 minutes
Courtesy carlier | gebauer
© carlier | gebauer and the artist 2009

Ronald Searle
Heads of executed Malay and Chinese civilians displayed in a Syonan [Singapore] street, 1942
Ink wash on paper
16.5 x 10.9
Imperial War Museum
© Ronald Searle 1942, by kind permission of the artist and The Sayle Literary Agency

Ronald Searle
In the jungle – fit parade for work, Thai-Burma railway: men with malaria, ulcers, beri-beri and dysentry, date unkown
Ink on paper
21.6 x 17.2
Imperial War Museum
© Ronald Searle 1942, by kind permission of the artist and The Sayle Literary Agency

Page 106
* Ronald Searle
In the jungle – working on a cutting. Rock clearing after blasting, 1943
Ink, pencil on paper
21.6 x 17.1
Imperial War Museum
© Ronald Searle 1942, by kind permission of the artist and The Sayle Literary Agency

Ronald Searle
Japanese Kempi (Gestapo), Singapore, 1944
Photostat on paper
27.3 x 15.1
Courtesy Imperial War Museum
© Ronald Searle 1942, by kind permission of the artist and The Sayle Literary Agency

Ronald Searle
Prison Camp Headgear: Eighteen Hats, Changi Gaol, 1944
Ink on paper
21 x 16.3
Courtesy Imperial War Museum
© Ronald Searle 1942, by kind permission of the artist and The Sayle Literary Agency

Ronald Searle
Pro-Japanese Sikh guard punishing British officer for failing to salute, Changi, Singapore, 1942
Ink on paper
22.2 x 17.1
Imperial War Museum
© Ronald Searle 1942, by kind permission of the artist and The Sayle Literary Agency

Page 104
Ronald Searle
Sick and dying: cholera – Thailand, 1943
Ink on paper
22.3 x 17
Imperial War Museum
© Ronald Searle 1942, by kind permission of the artist and The Sayle Literary Agency

Page 105
Ronald Searle
Sick and dying: prisoner dying of cholera, Thailand, 1943
Ink on paper
24.1 x 18.9
Courtesy Imperial War Museum
© Ronald Searle 1942, by kind permission of the artist and The Sayle Literary Agency

Page 107
Ronald Searle
Street scene, Singapore 1942. Heads of executed Malay 'underground' workers exhibited as a warning, 1942
Ink on paper
21.7 x 16.9
Imperial War Museum
© Ronald Searle 1942, by kind permission of the artist and The Sayle Literary Agency

Ronald Searle
The notorious form, Singapore, 1942
Ink wash on paper
18.2 x 25.4
Imperial War Museum
© Ronald Searle 1942, by kind
permission of the artist and The Sayle
Literary Agency

Page 24–5
Amie Siegel
Berlin Remake, 2005
2-channel video installation, colour,
sound, 14 minutes
Courtesy of the artist
© the artist 2009

Page 29
* Monika Sosnowska
Corridor, 2006/2008
Installation view at Schaulager, 2008
MDF, carpet and fluorescent lights
Dimensions variable
Courtesy the artist and kurimanzutto,
Mexico City
© Monika Sosnowska 2008
Photo credit: Tom Bisig, Basel

Page 81
George Stubbs
*A Comparative Exposition of the Human
Body with that of a Tiger and a Common
Fowl: Human Skeleton, Lateral View, in
Crawling Posture*, 1795–1806
Graphite on thin woven paper
28.2 x 44.8
Yale Centre for British Art , Paul
Mellon Collection

Page 98
* Sturtevant
Duchamp 11 rue Larrey, 1992
200 x 100
Wooden door, two wooden door frames
and metal door handle
Courtesy Galerie Hans Mayer, Anthony
Reynolds Gallery and Deichtorhallen
Hamburg
Photo by Maike Klein of installation
view at Deichtorhallen Hamburg,
August 1992.
© the artist 2009

Page 115
X-Radiograph of Titian's *The Death of
Actaean*, 1565–76
Duratran print, lightbox
178.8 x 197.8
© The National Gallery,
London

Mark Wallinger
Green Line barrier I, 2006
Stereoscopic photograph
© Mark Wallinger

Mark Wallinger
Green Line barrier II, 2006
Stereoscopic photograph
© Mark Wallinger

Page 97
Mark Wallinger
*Time and Relative Dimensions in
Space*, 2001
Stainless steel, MDF, electric light
281.5 x 135 x 135
Courtesy Anthony Reynolds Gallery
© Mark Wallinger

Page 52
Mark Wallinger
UN Post on the Green Line, Nicosia, 2006
Stereoscopic photograph
© Mark Wallinger

Additional Works

Page 51
Caravaggio
The Doubting Thomas, 1602–3
Oil on canvas
107 x 146
© Stiftung Preußische Schlösser und
Gärten Berlin-Brandenburg
Photo courtesy Stiftung Preußische
Schlösser und Gärten Berlin-
Brandenburg

Page 113
Cornelius Gijbrechts
The Reverse Side of a Painting, 1670
Oil on canvas
Courtesy Statens Museum for Kunst,
Copenhagen
© SMK Foto

Page 123
Pieter de Hooch
The Courtyard of a House in Delft, 1658
Oil on canvas
73.5 x 60
Courtesy National Gallery
© The National Gallery, London

Page 70
Mark Wallinger
Cricket wicket painted on wall, 2008
Courtesy the artist
© Mark Wallinger

Page 9
Mark Wallinger
Four postcards, 2001
Courtesy the artist
© Mark Wallinger

Page 18
Mark Wallinger
James Joyce centenary celebration,
Dublin, 1982
Courtesy the artist
© Mark Wallinger

Page 32
Mark Wallinger
Letter from Lucia Joyce, 1966
Courtesy the artist
© Mark Wallinger

Page 120
Mark Wallinger
Oxymoron, 1996
Flag
Dimensions variable
Courtesy Anthony Reynolds Gallery
© Mark Wallinger

Page 22
Mark Wallinger
Photo of Babelsberg film set, 2004
Courtesy the artist
© Mark Wallinger

Page 26
Mark Wallinger
Sleeper, 2004
Projected video installation 2hrs 31mins
Courtesy Anthony Reynolds Gallery
© Mark Wallinger

Page 118
Mark Wallinger
They think it's all over … it is now!, 1988
Paint, MDF Subbuteo football game
131.5 x 148.5 x 109.5
Courtesy Anthony Reynolds Gallery
© Mark Wallinger

Page 17, 60–1
Mark Wallinger
Zone, Münster Sculpture Project, 2007
Courtesy Anthony Reynolds Gallery
© Mark Wallinger

Page 48
Martian Terrain, Twin Peaks in super
resolution – left eye, 1997
Courtesy NASA/JPL
© NASA/JPL

Page 14
The French high wire artist, Philippe
Petit, walks across a tightrope suspended
between the World Trade Center's Twin
Towers, New York, 1974
Video still
© AP/PA Photos

Page 77
The tomb of Russian dancer Rudolf
Nureyev, 2008
Courtesy Getty Images
© 2008 AFP
Photo credit: Pierre Verdy/AFP/Getty
Images

Page 13
View after the collapse of the Campanile
at St Mark's Basilica, Venice, Italy, 14 July
1902
Courtesy Time & Life Pictures/
Getty Images
© Time & Life Pictures
Photo credit: Time & Life Pictures/Getty

Page 6
World Cup coin toss, 30 July 1966
Courtesy Getty Images/Hulton Archive
© 2007 Getty Images
Photo credit: Central Press/Getty Images

Exhibition curated by Mark Wallinger
Exhibition organised by Roger Malbert and Clementine Hampshire,
assisted by Rahila Haque

Art Publisher: Charlotte Troy
Publishing Co-ordinator: Giselle Osborne
Notes by Helen Luckett
Sales Manager: Deborah Power
Catalogue design: YES
Printed by Graphicom in Italy

Published by Hayward Publishing, Southbank Centre, Belvedere Road, London,
SE1 8XX, UK. www.southbankcentre.co.uk

Hardback: ISBN 978 1 85332 278 5
Paperback: ISBN 978 1 85332 272 3

Distributed in North America, Central America and South America through D.A.P./
Distributed Art Publishers, 155 Sixth Avenue, 2nd Floor, New York, N.Y. 10013,
tel: +212 627 1999, fax: +212 627 9484, www.artbook.com.

Distributed outside North and South America by Cornerhouse Publications, 70
Oxford Street, Manchester M1 5NH, tel. +44 (0)161 200 1503; fax. +44 (0)161 200 1504,
www.cornerhouse.org/books